Keys to Painting

Faces & Figures

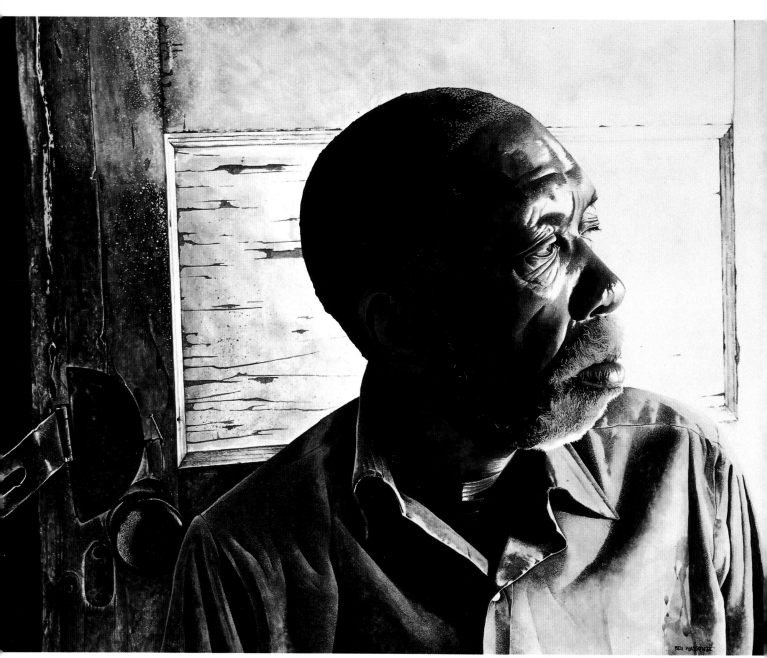

BEN WATSON III
Beyond Our Dreams
Watercolor, 21″×28″ (53cm×71cm)

Light can change the mood, shape and importance of everyday people.

Keys to Painting
Faces &
Figures

EDITED BY RACHEL RUBIN WOLF

NORTH LIGHT BOOKS

CINCINNATI, OHIO

The material in this compilation appeared in the following previously published North Light Books (the initial page numbers given refer to pages in the original work; page numbers in parentheses refer to pages in this book).

Greene, Gary. *Creating Textures in Colored Pencil* ©1996. Pages 84-85 (121-122), 88 (124), 89 (123), 91 (126), 92 (125), 93 (cover, 5)

Hammond, Lee. *How to Draw Portraits in Colored Pencil from Photographs* ©1997. Pages 54-55 (26-27), 57-62 (28-33), 82-84 (114-117), 93-96 (118-120).

Hill, Tom. *Painting Watercolors on Location with Tom Hill* ©1996. Pages 40-51 (56-67, backcover).

Katchen, Carole. *Painting with Passion* ©1994. Pages ii (113), 42-44 (110-112).

Macpherson, Kevin D. *Fill Your Oil Paintings with Light and Color* ©1997. Pages 62-67 (94-99).

Leveille, Paul. *Drawing Expressive Portraits* © 1996. Pages 24-29 (10-15), 32-37 (16-21).

Leveille, Paul. *Painting Expressive Portraits in Oil* ©1997. Pages 20-23 (22-25), 24-25 (34-35), 26-31 (38-43), 34-39 (46-51), 114-123 (100-109), 125 (6).

Rocco, Michael P. *Painting Realistic Watercolor Textures* ©1996. Pages 56-57 (90-91), 98-99 (92-93).

Stine, Al. *Painting Watercolor Portraits* ©1997. Pages 28-29 (36-37), 36 (44), 122 (45), 24-25 (54-55), 88-93 (76-81), 108-115 (82-89).

Wade, Robert. *Painting Your Vision in Watercolor* © 1993. Pages 76-80 (52-53), 52-53 (68-69), 50-51 (70-71), 26-28 (72-73), 29-31 (74-75).

Wolf, Rachel Rubin, ed. *Splash 4* ©1996. Pages 30 (8), 31 (2).

03 02 01 00 99 5 4 3 2 1

Library of Congress Cataloging-in-Publication Data
 Keys to painting: faces & figures.—1st ed.
 p. cm.
 Edited by Rachel Rubin Wolf
 Includes index.
 ISBN 0-89134-976-6 (pbk.: alk. paper)
 1. Face in art. 2 Human figure in art. 3. Art—Technique. I. Wolf, Rachel Rubin.
N7573.3.K49 1999
743.4—dc21 98-37527
 CIP

Content edited by Karen Spector
Production edited by Amy J. Wolgemuth
Designed by Pam Koenig
Production coordinated by John Peavler

ACKNOWLEDGMENTS

The people who deserve special thanks, and without whom this book would not have been possible, are the artists and authors whose work appears in this book. They are:

Betty C. Boyle
Gary Greene
Lee Hammond
Tom Hill
Carole Katchen

Ann Kullberg
Kay Polk
Kevin D. Macpherson
Paul Leveille

Michael P. Rocco
Al Stine
Robert Wade
Ben Watson III

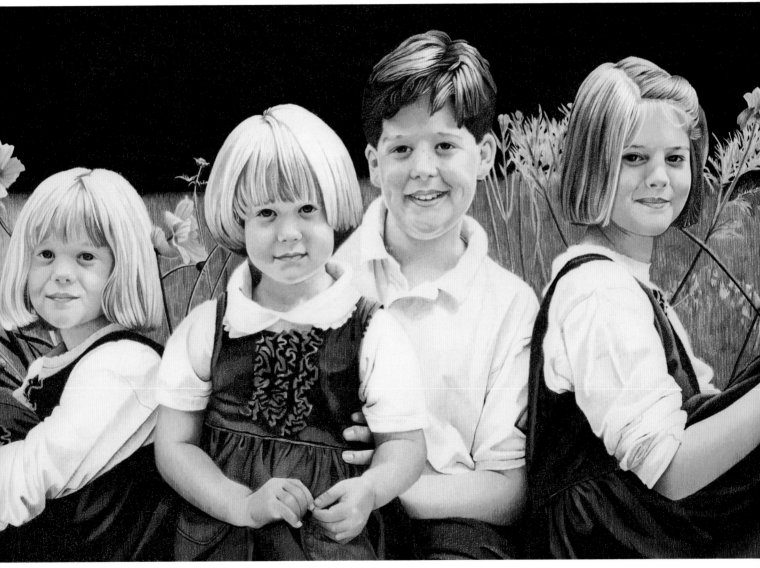

ANN KULLBERG
The Mannix Family
Colored Pencil, 20"×26" (51cm×66cm)

Colored pencil is well known for its high realism. Notice the significant amount of realistic detail in this portrait of the Mannix family children.

PAUL LEVEILLE
Whitney Richey
Oil, 28"×40" (71cm×102cm)

TABLE OF CONTENTS

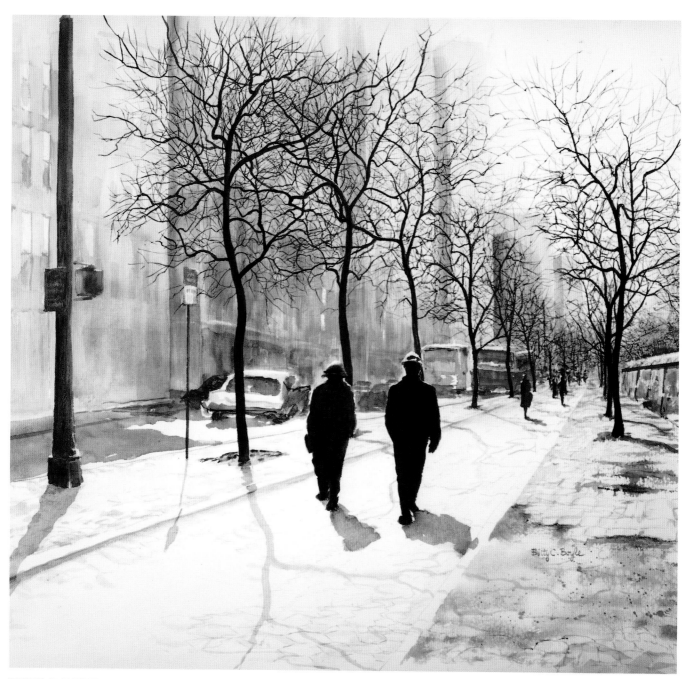

BETTY C. BOYLE
Morning in the City
Watercolor, 24" × 28" (61cm × 71cm)

This is a painting of a street in New York City. The people provide us with a variety of information, from the kind of day it is outside to the mood of the piece.

Imagine, if you will, a beautifully rendered watercolor painting of Times Square. With a crowd of shoppers and tourists populating the painting, it is suddenly able to convey the mood of the bustling city. Moreover, the people provide information about the time of year, time of day and weather conditions. People can also give viewers cues as to scale. This information may not otherwise be available to those looking at the painting.

Now imagine the painting once more. This time, focus in on one key figure: a young woman who is not walking but is looking up at the towering buildings above her. To one side, she has dropped her little red suitcase. She seems unsure of herself in these surroundings. With one solitary figure, you can shift the focus, mood and impact of your painting.

If faces and figures are the primary interest of your creative energies, you will find in this book a menu of tips and techniques for drawing and painting in a variety of media. Even if people are not the focus of your artwork, you will benefit from learning how to incorporate authentic figures into your drawings and paintings. You will find new ways to approach watercolor, oils, pastel and colored pencil with the practical ideas and demonstrations in the chapters that follow. You will learn techniques for creating a portrait, a moving figure, a crowd, and how to use light, shadow, composition and color to achieve your desired results. With visual awareness and practice you will be far on your way to mastering this key to painting.

Basics for Drawing and Painting
The Face

Simple Planes

The structure of the human head can be simplified by eliminating details and breaking down the many shapes into a few basic planes.

Practice drawing these heads, or, better yet, try working from a planed plaster (or plastic) cast. Once you feel more familiar with the head, then start drawing from a live model.

Whether you are working from a cast or a live model, it's important to use one main light source to accentuate the planes. In these drawings, the light source is above and to the left of the head. This lighting defines the features best by leaving shadow areas under the eyebrows, the nose, the upper lip and the chin. This is one of the most desired lighting situations for portraits since it reveals the forms of the features most effectively.

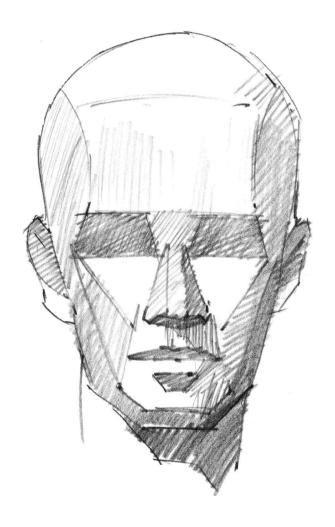

The area from the cheek down to the jaw is divided into three basic planes:
Light, where the light source is brightest;
Darker, as the form starts to turn from the light;
Darkest, as the form turns farthest from the light.

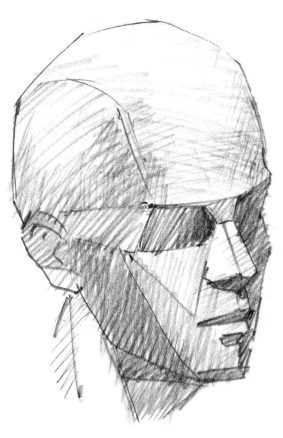

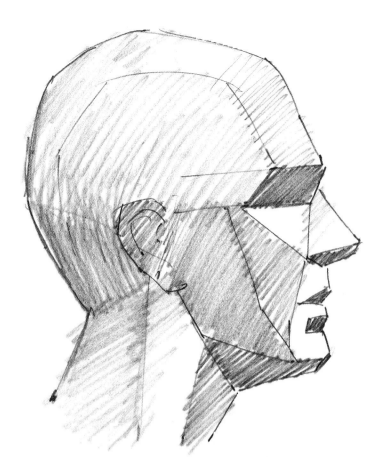

The way light is revealed on the planes of the head tells us how the head is shaped. Here, the jaw is dark because it turns back, away from the light. On the other hand, the ear is much lighter because it turns out from the jaw and catches the light.

The top and back of the head have the same appearance that a ball lit from above would have. Starting from the top of the head—the brightest area—the head gets progressively darker as the planes turn from the light to the back of the head. This produces the look of a rounded structure.

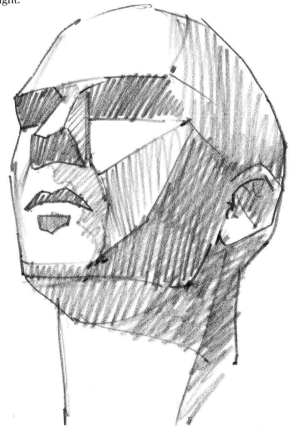

Try drawing the head in simple planes in a variety of positions. Remember to eliminate details. In this pose, eyes, eyebrows, nostrils, etc., have not been indicated.

The Head and Features

From the simplified planes of the head, we now progress to the study of the head and facial features. At this time, squint at these drawings. Squinting allows you to eliminate the details of the features and see only the big shapes—the planes. When you're drawing the head, always start with the big planes, then proceed to the smaller shapes and features, and finally to the details.

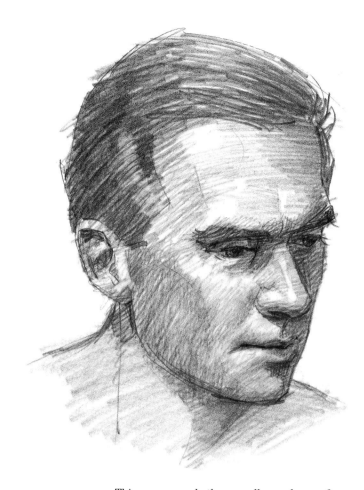

This pose reveals the overall roundness of the head. The brightest areas appear on the model's right forehead, the area above the cheek and the mouth area below the nose. As the forms turn away from the light they get darker.

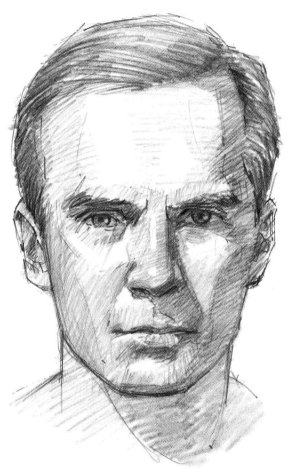

The big planes are still visible, but they are softer. For example, the transition from light to dark on the cheeks is more subtle. The eyes stay back in the shadow plane under the brows and are not as light as the forehead and cheek areas. The only bright light is the highlight.

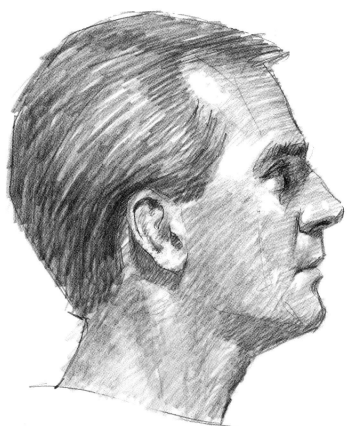

We've seen the subtle changes in planes on the cheeks. This pose reveals the dark planes caused by the canopy effect of the eyebrows, nose and jaw.

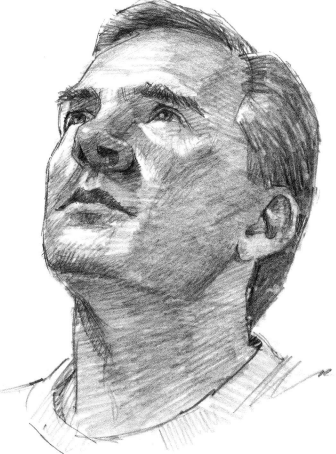

This pose lets us see what happens on the shadow side of the head. A lot of the planes are defined by reflected light. For example, the ear is entirely in shadow, but because it's turned at a slight angle to the head, it is picking up more reflected light. Keep in mind that even though the ear is lighter than the planes around it, it is still in shadow and therefore darker than features on the light side of the face.

Adult Head Proportions

All adult heads look different and yet they all have similarities, such as two eyes, two ears, a nose and a mouth. These similarities allow you to use the following basic proportions in drawing the head. See page 22 for a similar discussion with color illustrations.

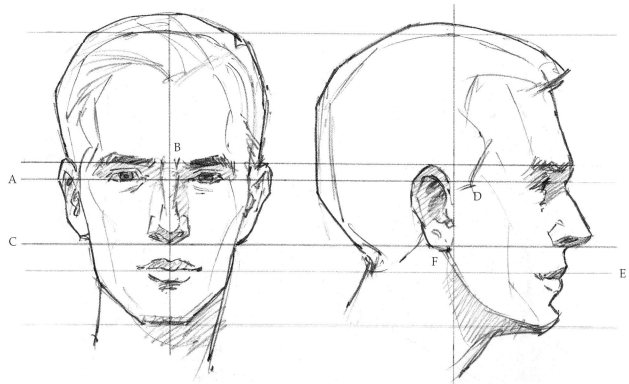

A From the top of the head to the chin, the eyes are positioned approximately in the middle.

B The eyes are about one eye-width apart.

C The bottom of the nose is halfway between the eyebrows and the chin.

D The ears are positioned between the horizontal lines of the eyebrows and nose.

E The mouth is placed between the nose and chin, about two-thirds of the way up from the chin.

F On the profile, notice that the ear is placed behind the vertical center line.

Drawing a Tilted Head

One way to help determine the tilt of a model's head is to imagine that the model has a clear bucket over his head. The cylindrical shape of a bucket is very similar to the shape of a head. If a model put a bucket over his head and tilted his head back, we could see into the open part of the bucket. In fact we would see the elliptical shape of the rim of the bucket. This same elliptical line can be used for the feature guidelines for the eyes, nose and mouth.

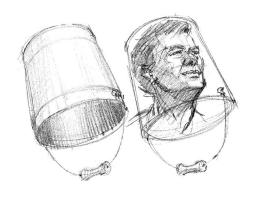

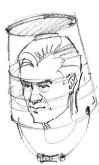

Study of a Man

1 INDICATE THE FEATURE GUIDELINES
When you start to draw a head, loosely sketch the overall shape. In this case it is egg-shaped.

Draw in the horizontal guideline for the eyes about halfway between the top of the head and the chin. Make this line an ellipse as though it were drawn around the outside of the egg. Do the same thing about halfway between the eyes and chin where the base of the nose will fall. Draw another ellipse about one-third down from the nose in the space between the nose and chin. Draw a fourth ellipse a little above the eyes. The eyebrows will fall on this line and it will help in positioning the top of the ear. Finally, draw in the vertical ellipse that will represent the center of the face. Once again, draw this ellipse around the outside of the egg shape.

2 ADD THE LARGE DARK SHAPES
Now squint at the model and sketch in the large dark planes indicated by shadow and by the hair. Use the side of your pencil to block in these areas quickly and loosely. Don't bear down on your pencil too much at this stage. Keep a light touch—you may want to make adjustments by erasing.

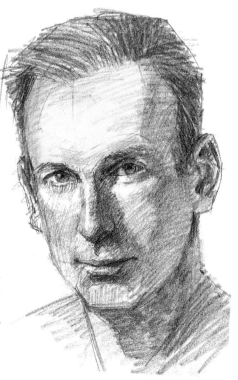

3 REFINE THE FEATURES
Once you have the big dark areas in place, start to refine the features. For example, try to draw the upward shape of the eyebrows. Then indicate the different tones within the eyebrows. They usually get darker just above the eye and lighter at either end. Remember to work from large shapes to small.

Children's Head Proportions

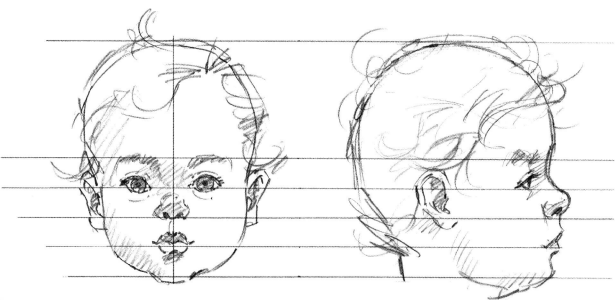

Baby

The eyebrows of a baby fall on the halfway line between the top of the head and the bottom of the chin. If you draw horizontal lines to divide the space between the eyebrows and chin into four equal parts, the eyes rest on the second line, the nose ends at the third line, and the lower lip rests on the fourth line. Note that the eyes are a little more than one eye-width apart. The top of the ear falls between the eye and eyebrow lines. The bottom sits a little above the upper lip and below the nose.

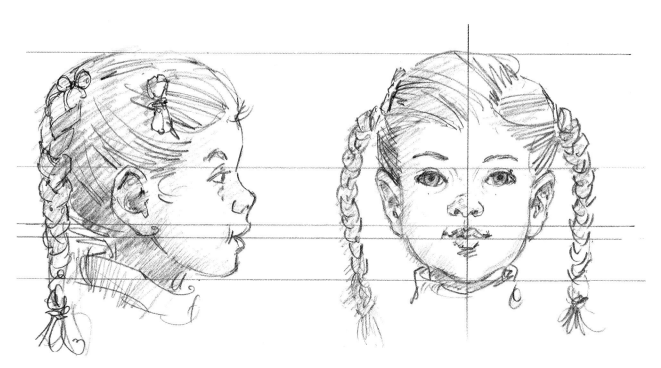

3-Year-Old Child

The horizontal halfway line falls slightly above the upper edge of the eyelids. The horizontal line running midway between the halfway line and the chin falls between the nose and upper lip. The ears are located between these two lines, but extend slightly below the upper lip. The bottom of the upper lip rests on the same line that the lower ear does.

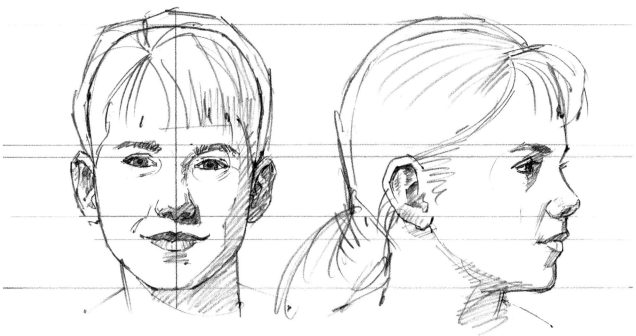

8-Year-Old Child

The eyes fall below the halfway mark. The nose is located halfway between the eyebrows and the chin. Lips are between the nose and chin about two-thirds of the way up from the chin. Ears start roughly at the eye line and end below the nose line.

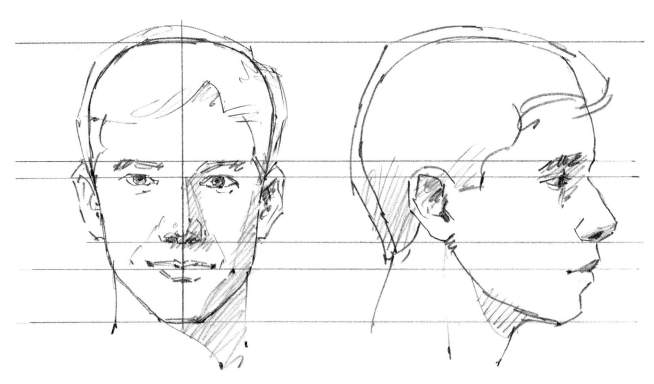

Teenager (Age 14-15)

Eyes are positioned roughly below the halfway line. The bottom of the nose falls halfway between the eyebrows and the chin. The bottoms of the ears start at the bottom of the nose. The tops are roughly at the eyebrow line. Lips are between the nose and chin about two-thirds of the way up from the chin.

Drawing a Baby's Head

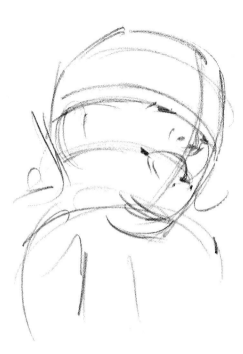

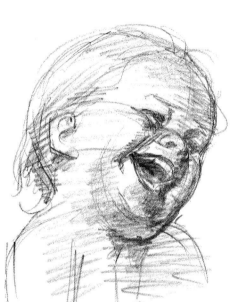

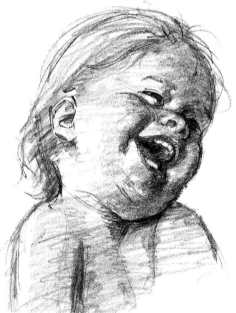

1 INDICATE THE OVERALL SHAPE
Knowing that the feature guideline that falls above the ears also runs above the upper edge of the eyelids, will help in positioning the features in this study. The addition of the vertical center line will position the tilt of the head.

2 ADD THE LARGE DARK SHAPES
Continue to loosely define the features. Once you feel comfortable with the position of the features, you can erase the guidelines. Squint and lightly draw in the big shadow patterns. Keep things simple.

3 REFINE THE DRAWING
Continue to refine the dark areas. Pull out the light areas on the eyelids, cheeks and side of the mouth with a kneaded eraser.

Drawing a 3-Year-Old Child

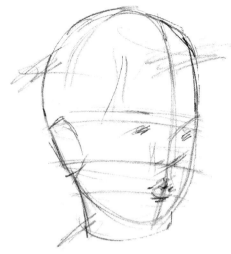

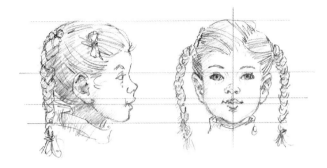

1 **INDICATE THE OVERALL SHAPE**
Usually a child's head is shaped more like a rounded egg than the elongated egg shape of an adult's head. All the child's features are located below the halfway mark of the head. The lower section is narrow while the upper section is larger and rounded like a ball.

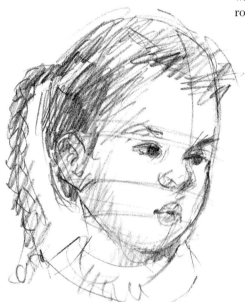

2 **ADD THE LARGE DARK SHAPES**
Once you have the features loosely in position, squint to find the largest dark shapes. They are the hair, including the braid, and the shadows under the left brow, alongside and under the nose, and under the chin. Sketch these areas in lightly, along with the light shadow area at the outside of the model's right cheek. Draw the basic shape of the features, but don't get too detailed at this time.

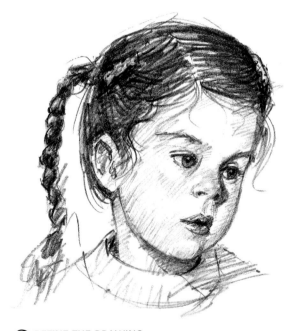

3 **REFINE THE DRAWING**
Now start refining your drawing. Let's take the model's right eye as an example. You've already drawn the almond shape and a dark area for the eye. Draw in the two lines above the eye that represent the lid. Lighten the white area of the eye with your kneaded eraser. Don't make it bright white; there is still a light tone of gray in that area. Next draw in the pupil very dark. Press the point of your kneaded eraser into the edge of the pupil to lift out a highlight.

Drawing an 8-Year-Old Child

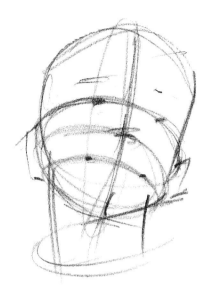

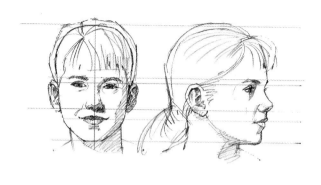

1 INDICATE THE OVERALL SHAPE
Due to the "worm's-eye view" perspective, the overall shape of this head becomes more rectangular than egglike. Draw in the feature guidelines. Notice how the ears fall far below the eyes.

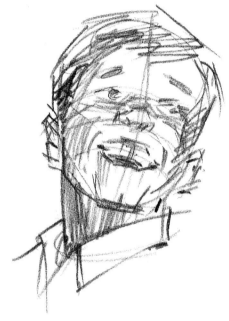

2 ADD THE LARGE DARK SHAPES
Once again look for the large dark areas—the hair and under the chin. Try to maintain the tilt of the head. Keep your guidelines in the drawing until you are satisfied with the position of the features.

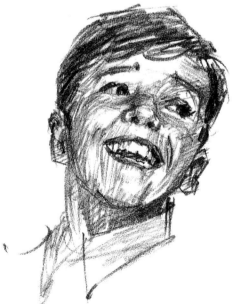

3 REFINE THE DRAWING
Continue working from the largest shapes down to the smallest. Save the detail work for the end. With the knowledge of the simple planes, feature guidelines, and with practice, you will be able to draw faces in any position.

Drawing a Teenager

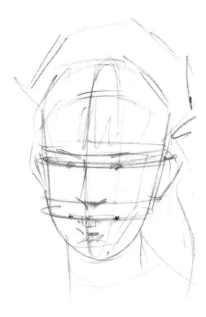

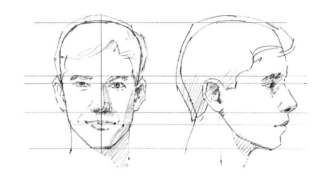

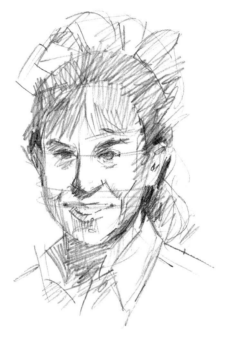

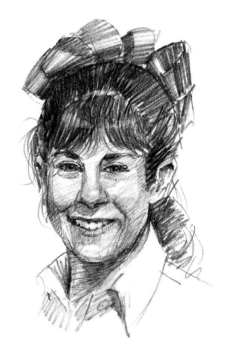

1 INDICATE THE OVERALL SHAPE

Start by loosely drawing the outer egg shape of the head. Also indicate the outline of the hair and bow (see step two). Draw in the horizontal elliptical feature guideline for the eyes. It falls halfway between the top of the head and the chin. Remember to draw in completely around the outside of the egg. The model's head is tilted down so we should be able to see the elliptical shape of the bottom of the clear bucket (see page 14).

2 ADD THE LARGE DARK SHAPES

Squint at the model to eliminate details and determine the overall form of the dark shapes. The dark areas on this model are the hair and the shadows under the brows, including the eye socket, as well as the shadows on the sides of the face, alongside and under the nose, under the lower lip and on the neck. Sketch them in lightly, striving to capture the correct shapes.

3 REFINE THE DRAWING

Begin refining the drawing slowly, once again starting with the largest shapes. The hair, for example, should be darkened. Keep your strokes going in the direction that the hair is combed.

Notice in the smile that each tooth is not completely drawn but suggested by adding darks under the teeth and on top. The darks suggest the shape of the teeth. Part of the area is in light while the rest turns away into the shadow area.

Painting the Features

The placement of the features is the same whether you are drawing or painting. Use either this model or the one on page 14 to make decisions about feature placement.

A Using a vertical line to divide the head, notice that the eyes are about halfway between the top of the head and the chin and one eye-width apart. The nose is about half-way between the eyebrows and chin, and the lips are between the nose and chin.

B The top of the ears are in line with the bottom of the eyebrows.

C The eyes are located halfway between the top of the head and the chin.

D The bottom of the nose falls half-way between the eyebrows and the chin. The bottom of the ears sits on line with the bottom of the nose.

E The bottom of the lower lip touches halfway between the nose and chin.

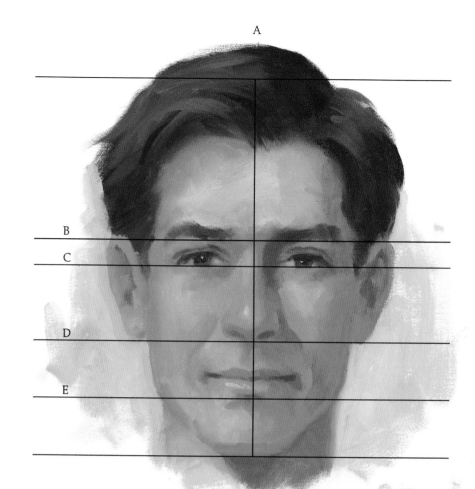

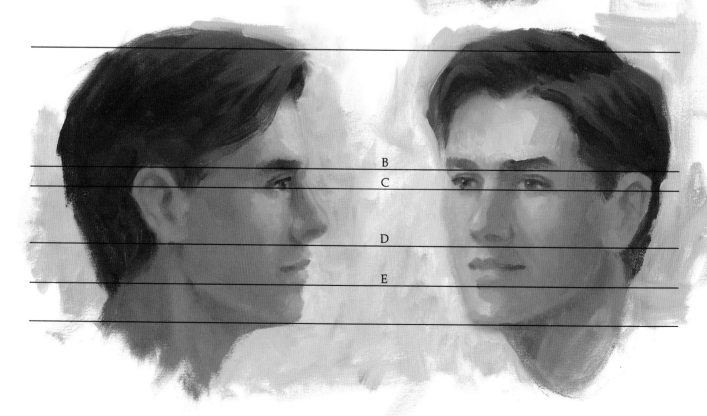

Tilting the Head

Here is a suggestion to help you understand how the location of the features will appear when the head is tilted. Turn a paper cup upside down and draw a horizontal line around the center. Draw the remaining feature guidelines as seen on the previous page. Now draw in the eyes, bottom of the nose, ears and lips in the appropriate locations on the cup. When you view the cup in various positions, you will be able to see how the features relate to each other.

In this sketch the head is tipped back. By tipping the cup back in the same position, you will find the features you've drawn on the cup relate to each other just as they do in the sketch. If you lay a pencil on this sketch under the ear in a horizontal position, you will notice that it intersects the bottom of the lower lip.

As you can see, the head in this sketch is tilted down. Try laying your pencil on this sketch as you did in the previous one. Notice when you line the pencil up under the ear that it now intersects under the nose.

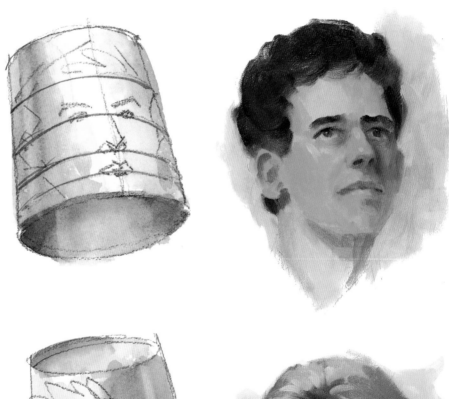

The Eyes

The eyes are usually the focal point in a portrait. They, along with the eyebrows, will reveal the mood of your subject more than any other feature. The movement of the eye itself, as well as the muscles around it, allow for a variety of expressions. You may have asked yourself, "How can I capture that expression? The sparkle? The twinkle?" "How can I paint that eye so it appears to be real?" In the following demonstration, you will see how to approach the construction of an eye, and bring it to completion.

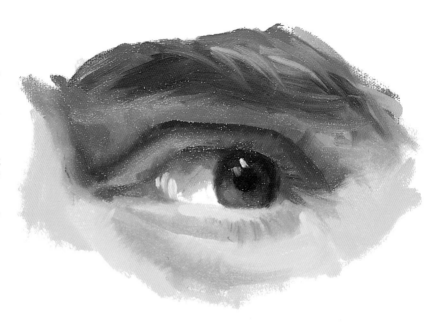

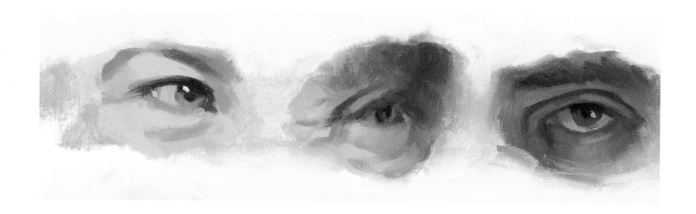

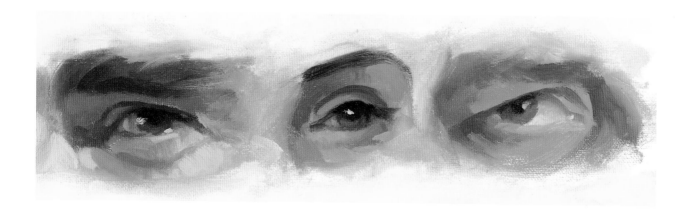

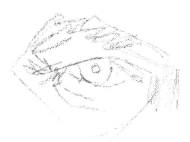

1 Using an HB charcoal pencil, lightly sketch in the eye on white canvas. Once you're satisfied with the sketch, give it a light spray of workable fixative. This will prevent the charcoal from smudging or mixing with the paint.

2 There won't be any solid white showing on the final painting, so the next step is to add a light skin tone over the entire area. For this skin tone, mix Cadmium Red Light, Yellow Ochre and lots of white. Scumble the paint on with your brush very lightly. You can still see the drawing through it.

3 Next, start building the halftone areas around the eye. These halftones are a little darker in value than the light areas. Paint these areas with a mixture of Cadmium Red Light, Raw Sienna and white.

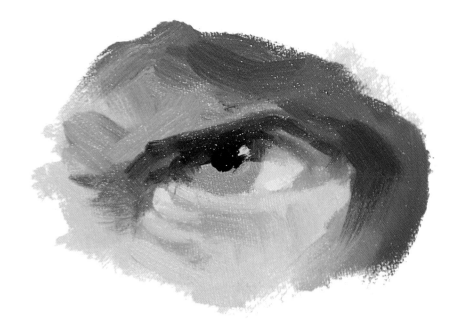

4 By squinting at the model, determine the shape of the darkest value areas. With a clean brush, mix Venetian Red, Ultramarine Blue, a little Cadmium Red Light and a touch of white for these areas.

As the forms turn toward the light, the colors get warmer as well as lighter. To achieve these warmer colors, add Cadmium Red, Yellow Ochre and a little white to the previous mixture.

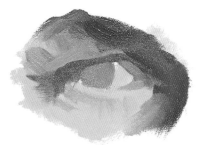

5 At this point, add a basic color and shape for the iris. Using a clean brush, mix Raw Umber, Permanent Green Light, Yellow Ochre and white to paint the iris. Paint the eyebrow area with a mix of Raw Umber and Yellow Ochre.

6 A shadow from the eyelid appears on the upper part of the iris. Paint this in with Burnt Umber. You will also use this color along the lash area of the upper lid. A rich dark is added to the right of the eye in the shadow area.

Using a no. 4 brush with a good point, mix a very light skin tone and add the highlight on the eye. Notice that it is positioned at a spot where it touches both the iris and the pupil.

Eyes

No other subject matter is changed more by the technique you choose to use. Look at how different all these eyes appear when rendered in a different fashion. Each one takes on a whole separate feeling since eyes show emotion. The colors you decide to use in your artwork should help portray the feelings you are trying to convey. The eyes drawn in color have a much warmer, happier look to them than the eyes done in gray tones. It is amazing how much impact color has.

The eye is made up of many interlocking shapes. Accuracy in these shapes is essential, not only in capturing your likeness, but also in making the eyes look toward the right direction.

You will want to use a circle template to draw the perfect circles required for the pupil and the iris.

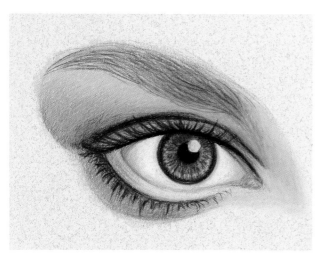

Full-color burnished Prismacolor.

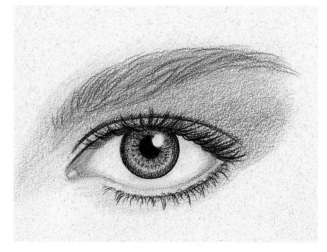

Full-color layered Verithin.

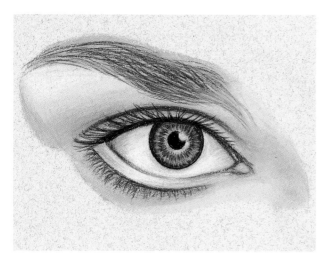

Black-and-white burnished Prismacolor.

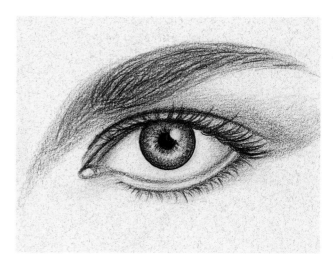

Black layered Verithin. All drawings done on Beachsand Artagain paper.

Brows and Lashes

Before we get into the complexities of the eye itself, let's start with some of the important details, such as the eyebrows, lashes and eye colors.

These exercises will help you master potential problem areas first, giving you a head start when you draw the open eye.

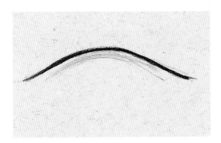

This is a lash line. It is usually quite dark and is seen on the upper eyelid. The lower lash line is very light.

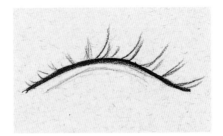

Begin applying lashes using very quick strokes with a sharp black Prismacolor. The strokes should originate at the lash line and taper at the ends. Look at how the lashes curve, as well as the direction they are going. Notice that eyelashes grow in clumps, not individually and all in a row.

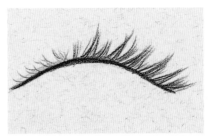

Continue adding lashes in random lengths and thicknesses. Use very light and quick strokes, and build them up gradually.

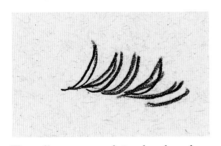

These lines are much too harsh and thick!

This is much better!

Draw the eyebrow as a shape and fill it in lightly and evenly with a sharp black Verithin pencil. (If this were being drawn in color, you would use brown.)

Slowly add hair lines using very quick strokes with a sharp black Prismacolor. Pay attention to the direction that the hairs are growing.

Continue filling until you get the fullness you want.

Adding some lines to the hair with a white Prismacolor can give the illusion of light reflecting.

Putting It All Together

You are now ready to draw the entire eye. Go slowly and follow the directions closely. Remember, this is a crucial element of portrait drawing. You must be proficient at drawing eyes if you want your portraits to have good character.

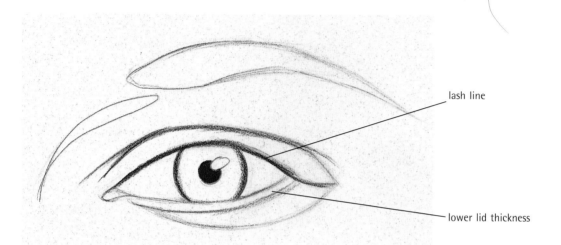

lash line

lower lid thickness

1 Use a circle template to draw the irises and pupils. With a black Prismacolor, blacken in the pupil. It is always centered in the iris. Notice how the catch light is half in the pupil and half in the iris. This gives the eye its shine. Darken the lash line and the area around the iris.

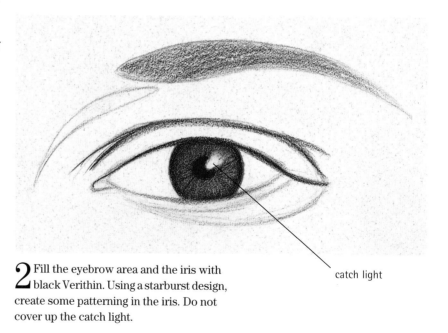

catch light

2 Fill the eyebrow area and the iris with black Verithin. Using a starburst design, create some patterning in the iris. Do not cover up the catch light.

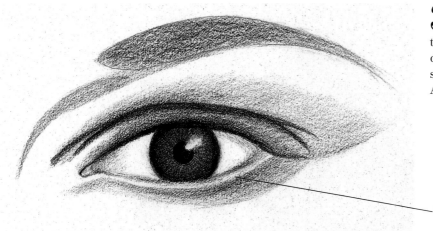

3 Begin placing tone on the eyelid, on the brow bone and below the eye. Look for the lower lid thickness. This gives the eye dimension and is necessary for realism. Be sure to leave it light since it reflects light. Add some subtle shadows to the eyeball.

lower lid thickness

4 Apply the eyebrows and eyelashes using quick strokes with a sharp black Prismacolor. Apply white Prismacolor to the catch light. This would be finished if done in Verithin only.

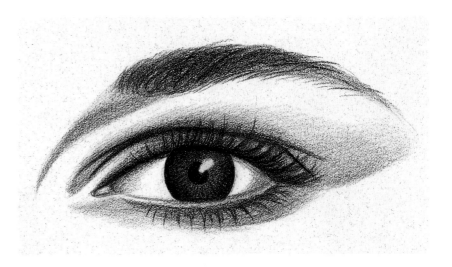

5 Burnish your drawing with a white Prismacolor, then reintensify the tones with black, blending them together with the white. This technique makes eyes look shinier.

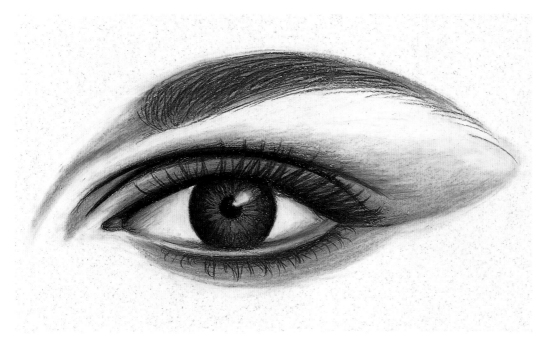

Eyes in Full Color

FEMALE

Let's draw some eyes now using color, exploring the differences between male and female eyes.

The most recognizable difference between the two is in the eyebrows. Men usually have thicker eyebrows with less arch to them. Their eyebrows and brow bone are often closer to the eyes. Women, on the other hand, usually have thinner brows with more arch.

Cosmetics will often make a women's eyes stand out more, with the eyelashes seeming more full and noticeable. But be careful. Every person is different, and there are exceptions to every rule and generality. Study your reference carefully. You must draw the features as they appear for that particular individual.

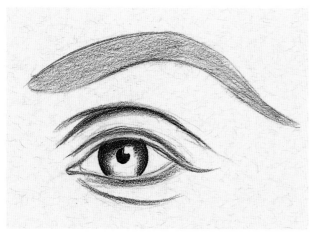

1 Start with an accurate line drawing. Begin replacing graphite with Dark Brown Verithin. Fill in the eyebrow area with Dark Brown also. With a black Prismacolor, fill in the pupil, but be sure to leave a catch light. (Remember, half in pupil and half in iris.) Darken iris area with black.

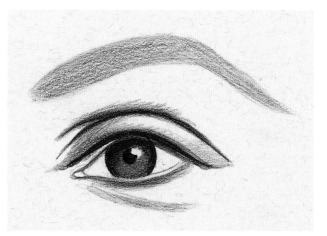

2 Add more Dark Brown Verithin to the lid area and eye crease above the eye. Apply Dark Brown below the lower lid thickness. Add Dark Brown to the iris.

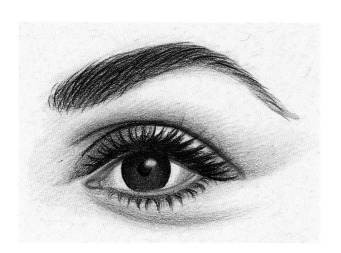

3 Add Flesh Verithin to the skin tones. Add Tuscan Red to the eye crease, inner eye membrane and along the lower lid thickness, and some to the shadow below the eye. Deepen the eye color with Dark Brown. Add white Prismacolor to the catch light. Finish by adding eyebrows and eyelashes. Notice how the lashes on the lower lid grow off the lower lid thickness. You *must* have a separation between iris and lashes or the eyes will look outlined and unreal.

MALE

The man's eye was drawn on Beach-sand Artagain paper, which has more of a yellow tone to it than the paper used for the woman's eye. Draw this eye using the same procedure from the previous exercise. Notice how the man's eye has more eyebrows but fewer eyelashes. Since this eye is looking in a different direction, it will be very important to place the iris and pupil in the proper place.

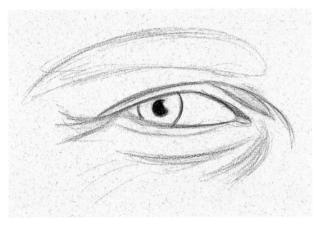

1 After drawing the line lightly in graphite, the pupil is filled in with black Prismacolor.

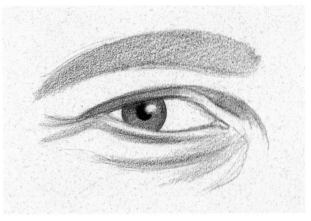

2 Dark Brown Verithin is added to the iris, shadow areas and eyebrow. Black Verithin is added around the outside edge of the iris.

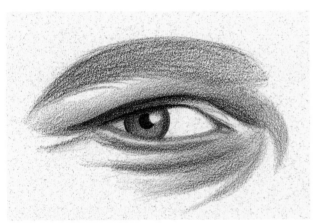

3 Tuscan Red Verithin is added above the eyelid, helping create the curve of the brow bone. Tuscan Red is also placed in the corner of the eye membrane and into the shadows beside and below the eye.

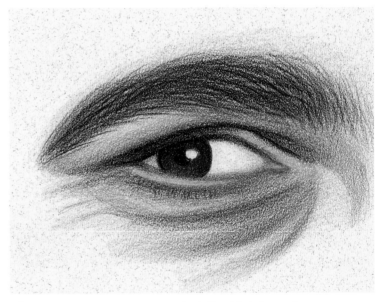

4 To create realistic skin tones, Flesh Verithin is layered into Tuscan Red. A light touch helps the colors blend and gently fade into the color of the paper. Dark Brown Prismacolor was added to the iris for strength of color. White Prismacolor was added to the catch light for shine.

Looking in a Different Direction

In the previous exercise, the face is turned with the eye still looking toward you. But what happens when the eye looks away from you? We have learned that the iris and pupil of the eye are perfect circles, which is extremely important. But this is only true if the eye is looking directly at you. When the eye looks in a different direction (and away from you), what you see is no longer a perfect circle. What you are seeing is a circle in perspective, or an ellipse.

Study this eye. At first glance, the iris does appear to be a perfect circle. But closer observation will show you that it is actually a subtle vertical el-lipse. If it *had* been drawn as a perfect circle instead of the ellipse, it would have changed the gaze and direction of the eye, making it appear to straighten out and look toward you.

Whenever you have eyes that are looking away from you, whether it be from side to side or up and down, you will be dealing with ellipses rather than circles. A template is still necessary to achieve the right shape, so purchase templates with both circles and ellipses. Don't be tempted to try to freehand the eyes. Both eyes must be the same shape and size, and if you plan on drawing portraits, it will be well worth the investment of a few dollars!

A vertical ellipse is used for the drawing below.

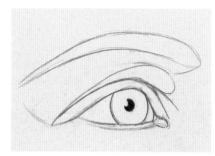

1 Begin with an accurate line drawing on Shell Renewal or peach-colored paper. Use an ellipse template to draw the pupil and the iris. The pupil is still centered in the iris, even when working with ellipses. Darken the pupil with a black Prismacolor. Do not forget the catch light.

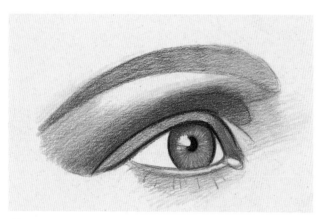

2 Begin layering colors with your Col-erase pencils. Use In-digo Blue and black for the iris. Use black for the lash line and eye crease. Apply more Indigo Blue to the eyelid and above the eye crease.

Apply Tuscan Red over the blue above the eye. This will create a violet shade. Apply more Tuscan Red into the corner of the eye and fill in the eyebrow area. Also shade the brow into the crease of the eye with Tuscan Red to make the area above the eye look rounded, and shade below the lower lid thickness.

Apply some Flesh Col-erase pencil as a transitioning color to soften the Tuscan Red into the color of the paper.

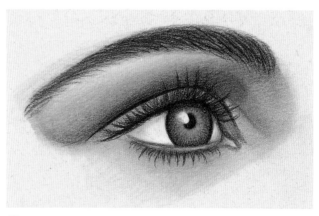

3 Blend out all the tones with tortillions, using one for the blue areas and one for the flesh tones. (This keeps the dark colors from dragging into the lighter ones.)

Finish the drawing by adding white Prismacolor to the center of the iris for decoration and to the catch light. (See how shiny the eye now looks?)

Add brows and eyelashes with a sharp black Prismacolor.

Proper Alignment

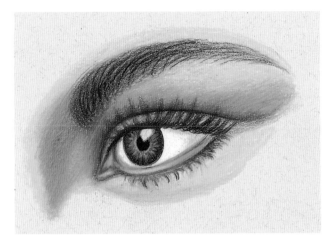

The iris and pupil in this eye are vertical ellipses.

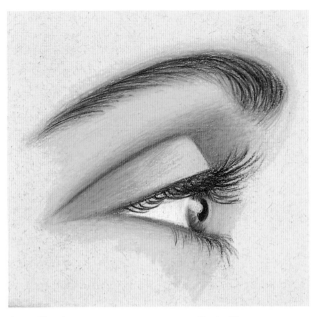

A profile view creates an extreme vertical ellipse.

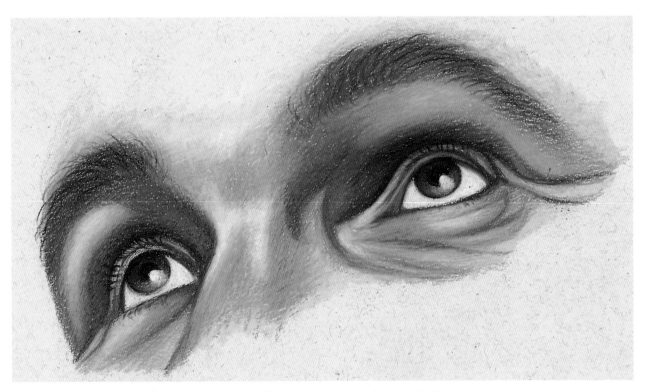

Since these eyes are looking up, and not side to side, they are creating horizontal ellipses.

The Nose

One of the most prominent features of the human head is the nose. Because of the way it protrudes, it is often seen one side in light while the other side is in shadow. This makes for an excellent example of how to construct a feature by painting the big shapes (lights and darks) first. The following demonstration will explain the step-by-step process.

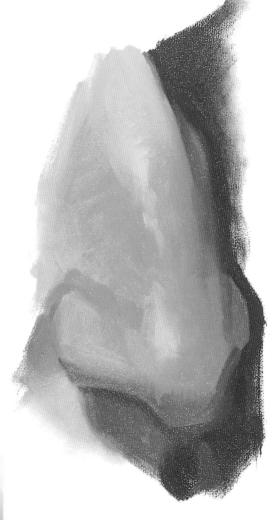

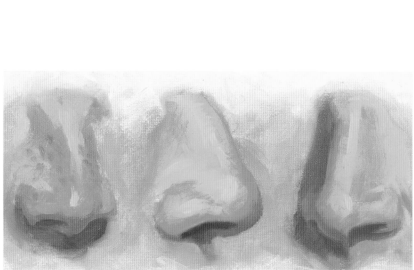

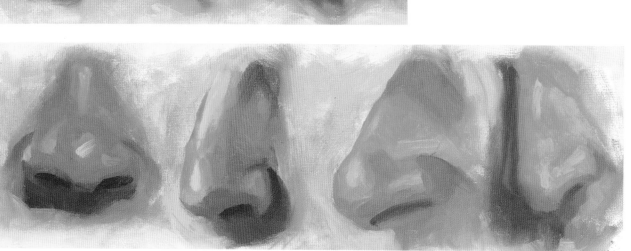

1 Using a 2B charcoal pencil, lightly sketch in the nose on canvas. When completed, spray the sketch with workable fixative.

2 Since there is no solid white on the model's nose, we want to get rid of the white on the canvas. Mix Cadmium Red Light, Yellow Ochre and white. This mix is lightly scumbled over the drawing with the side of the brush.

3 For the warm halftones, use the same skin mixture with a little more Cadmium Red and Yellow Ochre added. Paint this mixture on the bridge of the nose and on the wing of the nostril on the light side of the nose.

4 By squinting at the model, you see the shadow side of the nose as one dark shape. To paint this shape, use a mix of Indian Red, Ultramarine Blue, a little Cadmium Red Light and a touch of white (just enough to see the color of the mixture). Start with a bold stroke down the side of the nose.

5 More Cadmium Red Light and white are added to the mixture for the underside of the nose.

6 In order to make the area between light and dark look rounded, add a halftone. Mix Cadmium Red Light, Raw Sienna and white. Apply this color with your brush between the dark and light shapes along the bridge and the bulb of the nose. You can also use this mixture for reflected light under the nose and on the wing of the nostril lying on the shadow side of the nose.

7 Mixing Cadmium Red Light, Yellow Ochre and white with your brush, paint some warm tones along the light side of the bulb of the nose and the bridge. Add more Yellow Ochre and white for the lighter areas of the bulb and bridge.

8 Using the tip of a no. 4 brush, add highlights to the bridge and the end of the nose. The highlights are a mix of Cadmium Red Light, Cadmium Yellow Light and lots of white.

The Mouth

The mouth is the second most expressive feature of the face. The shape of the mouth is largely determined by the curvature of the bone and teeth. The most forward part of this curve is at the center of the mouth, and then it curves back toward the cheeks. Correspondingly, the lips are fullest in front and become thinner as they recede. In repose the mouth is fuller than at any other time. No feature is more flexible than the mouth. The upper lip remains fairly stationary while the lower lip moves with the up-and-down motion of the lower jaw. At the same time, the lips curve into all sorts of common and unlikely shapes.

To draw the mouth correctly, it is helpful to think of the lips as having five muscles: three in the upper lip and two in the lower lip.

There are slight depressions where the corners of the mouth run into the lower cheek. These depressions are usually more pronounced on a man than on a woman. In the frontal view, the convex features of the mouth are affected by the teeth and the corners are farther back than the middle. The curvature of the lips as they near the corners is a bit foreshortened. Always establish the relationship of the corners of the mouth to the middle before going into detail.

When drawing the mouth in profile, notice that the lips usually slope backward on a line from near the tip of the nose to the furrow at the top of the chin.

SOFTEN THE EDGES OF THE LIPS

When painting the mouth, it is necessary to soften the edges of the lips in order to make them look like a natural part of the face. This softening process takes practice and needs to be done while the paint is still wet. If you wait until the paint has dried, it will be difficult to soften and most likely it will take on an overworked look. There are two ways to soften these edges. The first is to rinse your brush in clean water, shaking out the excess water, and then touching the brush to the outer edge of the lips, moving it up and away at about a 45-degree angle. The second, and perhaps easier way, is to again rinse the brush in clear water, touch the brush about 1/2-inch above the lip and then bring the brush down at a 45-degree angle to the edge of the area to be softened. Do only this and get out. Don't try to make it better by tickling it to death. If you are working very juicy and wet, wait a moment longer before softening an edge or it will run too much. This is something that will come only with practice.

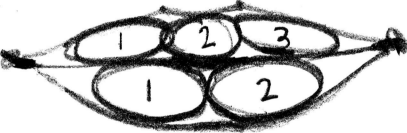

Think of the mouth as having five muscles in the lips: three in the upper lip and two in the lower lip.

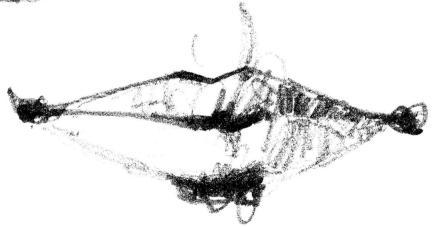

The upper lip is normally darker than the lower lip because the source of light is generally from above and to one side of the head.

When smiling, the upper lip stays on a flatter plane and is narrower than the lower lip, which with the lowering of the chin, is fuller and more sensuous.

When the head is tilted back, we see more of the teeth, and the upper lip takes on a very distinct curve while the lower lip flattens out quite a bit.

Soften the lipline so the mouth does not look cut out and pasted on. While the paint is still wet you can touch the edges with a clean, damp brush and move away from the lipline, softening it into the face. Or you can move from the face to the lipline allowing the color on the lip to run into the clear water on the face.

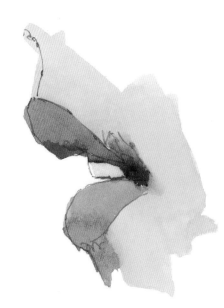

This is a side and three-quarter view of the mouth showing how the various edges are softened into the face.

The Lips

They move, they stretch, they pucker. The lips are one of the most animated features of the human head. The important thing to keep in mind is that the lips are part of the muscles that form the muzzle area of the face. For this reason, it is necessary to paint the forms around the lips first. The following demonstration is a good example of this approach.

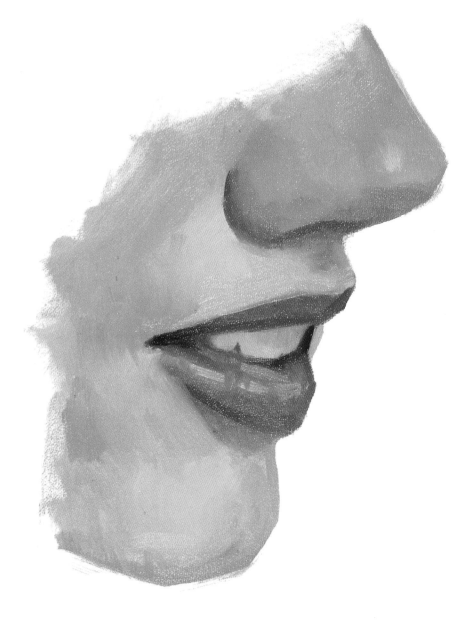

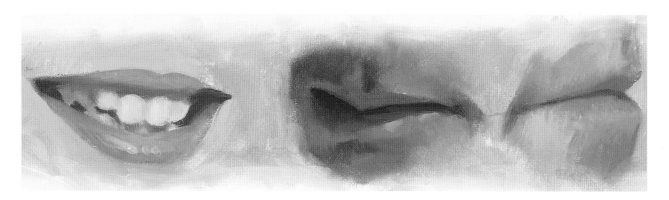

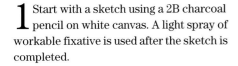

1 Start with a sketch using a 2B charcoal pencil on white canvas. A light spray of workable fixative is used after the sketch is completed.

2 Scumble a light mixture of Cadmium Red Light, Cadmium Yellow Light and white over the sketch and around the lip area with the side of your brush.

3 Next, build the area around the lips. The darker areas are painted with Cadmium Red Light, Yellow Ochre, Permanent Green Light and white. For the lighter values, use Cadmium Red Light, Cadmium Yellow Light and white.

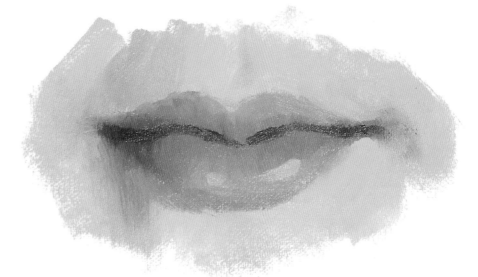

4 By squinting at the model, simplify the shape of the darkest area of the lips—paint this with a mix of Cadmium Red Light, Raw Umber and white. Mix a middle value color of Cadmium Red Light, Yellow Ochre and white and paint the middle tones.

6 At this point, add the darks between the lips with a nicely pointed no. 4 brush. Vary the stroke and weight of this line for a more natural look. Use a mix of Burnt Umber, Cadmium Red Light and white.

Finally, add the highlights with a mix of Cadmium Red Light, Yellow Ochre and lots of white. Paint a touch of a light lip mixture at the top of the lips to soften the transition to the skin.

5 Paint the light areas of the lips with a mixture of Cadmium Red Light, Yellow Ochre and white. Reaffirm the dark areas of the lips and increase the darkness of the values of the skin on each side of the mouth.

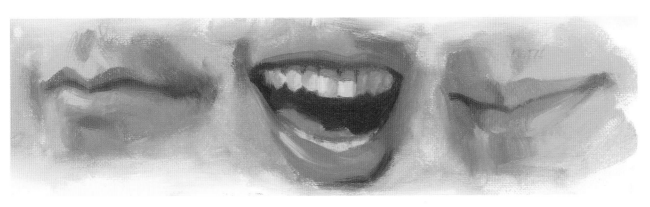

The Ears

Those wonderful hearing devices attached to the sides of our heads sometimes appear to be a complicated mix of folds and dips and curves. The best way to approach painting ears is to keep it simple. Look at the overall shape. Then break that shape down into simple dark and light shapes. The following demonstration will help you master this approach.

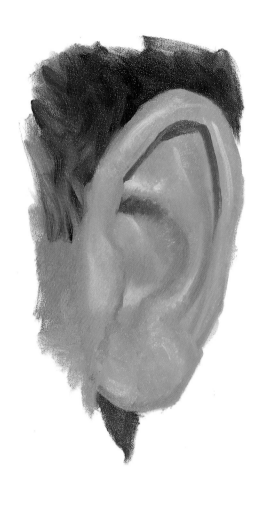

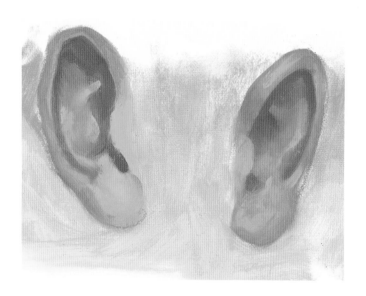

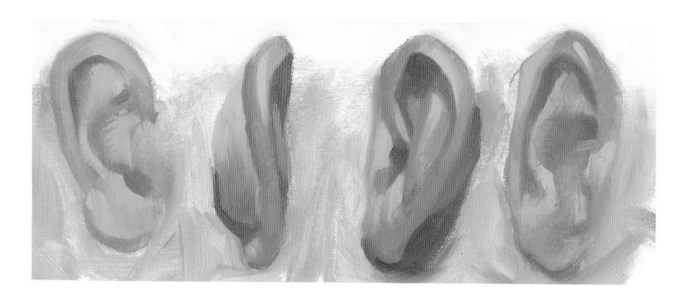

1 Start with a light charcoal sketch on white canvas. When the sketch is completed, give it a light spray of workable fixative.

2 To eliminate the white canvas, use the side of your brush to scumble on a light skin tone made up of Cadmium Red Light, Yellow Ochre and white.

3 Next, look for the big halftone areas—those shapes between dark and light—and paint them in with a mix of Yellow Ochre, Alizarin Crimson and white.

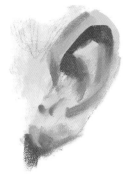

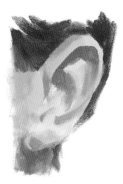

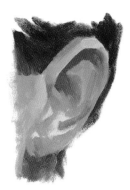

4 Squinting at the model, determine the shapes of the dark areas of the ear. Using a mix of Venetian Red, Ultramarine Blue, Cadmium Red Light and a touch of white, paint the dark areas in. As the form turns from dark to light, add Cadmium Orange to the mix.

5 Paint in the hair and skin around the ear so it won't appear to be floating in space.

6 Now paint the smaller value and color areas within the large dark and light shapes. For the shapes in the light areas, use Burnt Sienna, Cadmium Red Light, Yellow Ochre and white. For the warm dark areas (such as the bowl of the ear), use a mix of Venetian Red, Cadmium Orange and white.

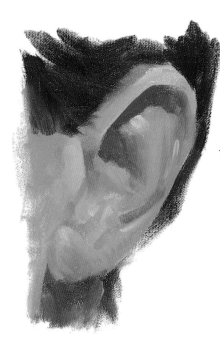

7 Now define the lightest areas with Cadmium Yellow Light, Cadmium Red Light and white. Finally, using a no. 4 brush, add the highlights using the above mixture with more white added.

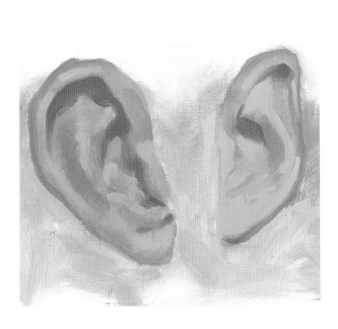

The Hair

What other feature can wear so many hats? (No pun intended!) Hair comes in many colors and textures, and a variety of lengths. And don't forget beards and mustaches. Once again, simplicity in approach is the key to painting believable hair.

1 Start with a charcoal sketch on white canvas. As in the previous demonstrations, give this sketch a light spray of workable fixative.

2 Since hair grows out of the skin, it is necessary to add a skin tone not only to the face, but over the hair as well. With the side of your brush, scumble a mix of Cadmium Red Light, Yellow Ochre and white.

3 Paint the middle-value areas of the hair with a mix of Raw Umber, Yellow Ochre and white.

4 It is important to shape the forehead and temple areas in order for the hairline to blend naturally in those areas. Start by painting in the darks with Venetian Red, Ultramarine Blue, Cadmium Red and a touch of white.

5 Now add the dark shapes in the hair using Raw Umber, Yellow Ochre and white.

6 For the light areas of hair on the shadow side of the head, use Raw Umber, Raw Sienna and white. Be careful not to make this color too light, as it is still in the shadows and not receiving as much light as the light side of the head.

7 For the light areas of hair on the light side of the head, use Raw Umber, Yellow Ochre and more white. For some of the warmer areas, add a touch of Burnt Sienna to the mix.

8 A very light mix of Raw Umber, Yellow Ochre and lots of white is used for the highlights. Keep your brushstrokes moving in the direction of the hair for a more natural appearance.

Painting Hair and Beards

When painting hair either on the head or face, soften the edges at the face so it doesn't appear as though it were cut out and pasted on like a bad hairpiece. When using a round brush, lay the brush on its side and drag it along the length of the hair to get some interesting textures, keeping everything from looking too flat. Use a flat brush in the same manner, laying the brush on its side and dragging, sometimes even pushing it, to attain a desired texture. First draw and paint the planes or shapes of the hair as a whole, rather than each individual hair, leaving all detail work to be added later.

Softening the inside edges of the hair and beard creates the illusion of three-dimensional form. The viewer sees the round form of the head with areas such as the chin and nose coming forward, while other parts such as the ears seem to recede. Try to get a variety of rough, soft and hard edges for added interest and form.

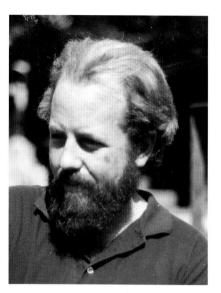

Reference photograph.

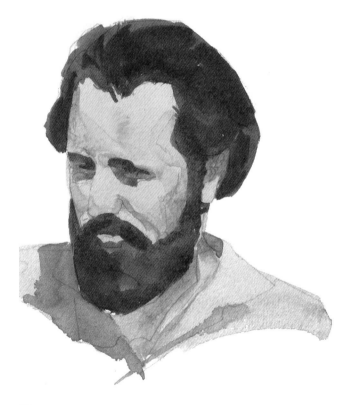

Wrong
This painting was done with hard edges around the hair. There was no softening of the hair or the beard into the face or background. You can see the "cut-out and pasted-on" look that resulted.

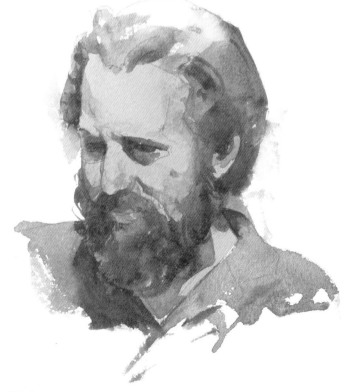

Right
In this painting, the hair and beard are softened into the face and background. This is a much better solution.

A Bearded Man

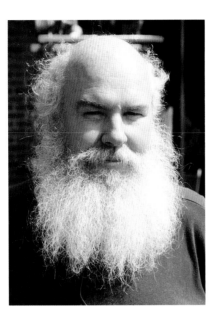

This man's face captured the interest of artist Al Stine. Stine met him at an outdoor art and craft show where he was displaying his beautiful pottery. He allowed Stine to photograph him.

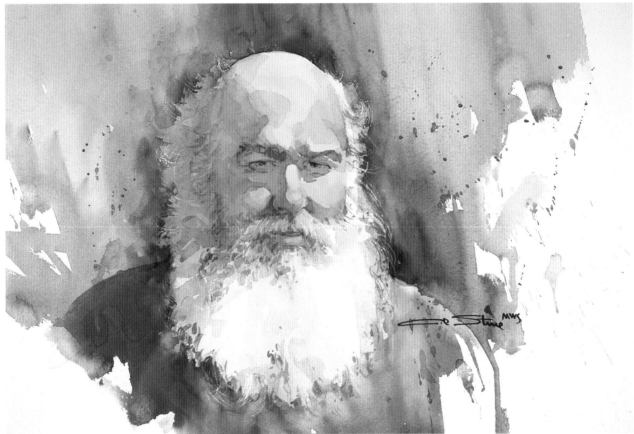

AL STINE
Steve
Watercolor, 13" × 20" (33cm × 51cm)

After the basic skin colors are dry, add Cadmium Red to the nose, cheeks and lips—normally the warmest areas of the face. Then strengthen the shadow areas in the beard and hair, and scratch out some white hairs with a razor blade. When painting hair of any kind, avoid the temptation to overwork it by painting every strand. Try to simplify, leaving much to the viewer's imagination.

Value Scale Exercises

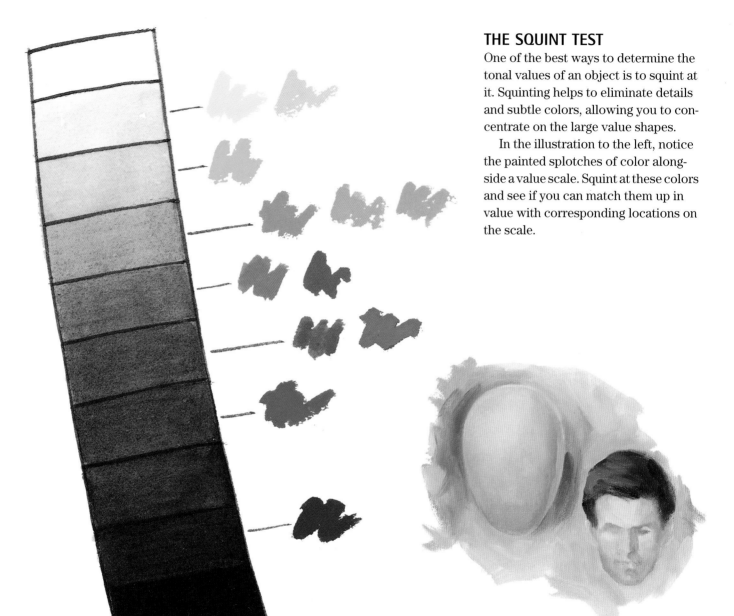

THE SQUINT TEST

One of the best ways to determine the tonal values of an object is to squint at it. Squinting helps to eliminate details and subtle colors, allowing you to concentrate on the large value shapes.

In the illustration to the left, notice the painted splotches of color alongside a value scale. Squint at these colors and see if you can match them up in value with corresponding locations on the scale.

This illustration is a good example of how values change on an object due to the amount of the light it is or is not receiving. The egg, although smoother and minus the nooks and crannies of the human head, still has the same overall shape. When the egg is lit from above, we can see that the brightest (highest value) of the egg is at the top. As the contour or side of the egg turns down and away from the light it gets darker in value. Notice how the man's head to the right of the egg works the same way. To make this example even more obvious, turn the book around and view the illustration upside down.

Making a Value Scale

Although you can use any medium to make a value scale, pencil might be the easiest. Start by drawing a rectangular box 10″ high and 1½″ wide on a piece of heavyweight paper. Next, divide the 10-inch dimension into ten 1-inch sections. (For metric measurements, start with a box 25.4cm high and 3.8cm wide and divide it into ten sec-

tions.) Now fill in the bottom box with a soft pencil, such as a 6B or 4B, so that it is a dense black. Next, move your pencil rapidly back and forth, working your way up the scale. Don't be concerned about going outside the lines. As you move up, apply less pressure so that the gradation of pencil marks gets lighter. Try to get an even progression

from black at one end of the scale to white at the other. When you have finished, redraw the horizontal lines that separate the scale into ten parts. Spray the scale with workable fixative to prevent smudging, and cut it out. (This will make it easier to use.)

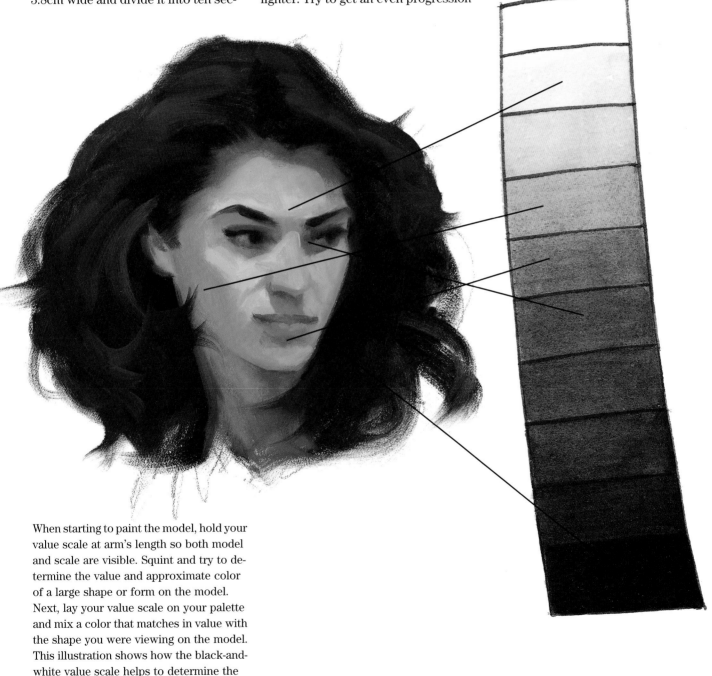

When starting to paint the model, hold your value scale at arm's length so both model and scale are visible. Squint and try to determine the value and approximate color of a large shape or form on the model. Next, lay your value scale on your palette and mix a color that matches in value with the shape you were viewing on the model. This illustration shows how the black-and-white value scale helps to determine the values of colors on the model's head.

Mixing Colors

Color mixing can be lots of fun. It can also be frustrating until you get the hang of it. Rather than just listing a bunch of possible skin tone mixtures, study the four heads with different skin and hair coloring. Alongside each head are the instructions and mixtures used to achieve different colors and values. As you look at the color swatches for each mixture, notice the small swatches of each color used in a mixture above a larger swatch of the final mixed color. Mixing instructions are somewhat like Grandma's recipes—"a pinch of this" and "a dash of that." However, with a little practice you should be able to duplicate these mixtures. A few notes to keep in mind while mixing colors:

1. Mix your colors on your palette with a brush rather than a palette knife. Mixing is quicker and more thorough with a brush. Mixing on the palette will keep your colors cleaner, as mixing colors on the canvas can easily produce mud.

2. Keep in mind that the Cadmiums, along with Venetian and Indian Red, are very strong tinting colors and should be used sparingly when starting a mixture.

3. When mixing light colors, start by putting some white on the palette, and then adding colors to it.

The warm lighter areas of hair consist of the same mixture as below with Cadmium Red Light and more Yellow Ochre and white added.

For the light skin color of the forehead, use a touch of Cadmium Yellow Light, a touch of Alizarin Crimson and lots of white. For the warm blush color of the cheeks, use the same colors from the forehead mixture, but increase the strength of Cadmium Yellow Light and Alizarin Crimson in the mixture.

The dark areas of hair are Burnt Umber, Yellow Ochre and a touch of white.

This warm gold dark consists of a little Alizarin Crimson, Raw Sienna and white. The dark value under the jaw consists of Cadmium Yellow Light, Alizarin Crimson and white.

The warm tone of the ear is Cadmium Red Light, Yellow Ochre and white.

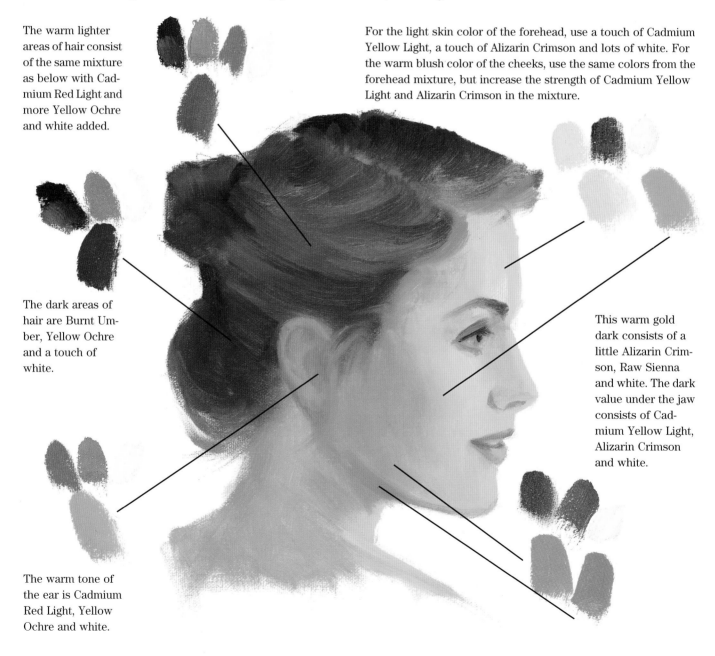

The light area of the forehead is a mix of Cadmium Red Light, Yellow Ochre, Cadmium Yellow Light and lots of white.

The dark hat consists of Ultramarine Blue, Ivory Black and Alizarin Crimson.

These rich, warm darks are made up of Venetian Red, Permanent Green Light, a touch of Cadmium Red Light and a touch of white.

For this ruddy cheek area mix Cadmium Red Light, Yellow Ochre, a little Cerulean Blue and lots of white.

The light area of the mustache is Raw Umber, Cerulean Blue and white.

This greenish area consists of Cadmium Red Light, Yellow Ochre, Permanent Green Light and white.

The warm dark of the beard is Raw Umber, Yellow Ochre and white.

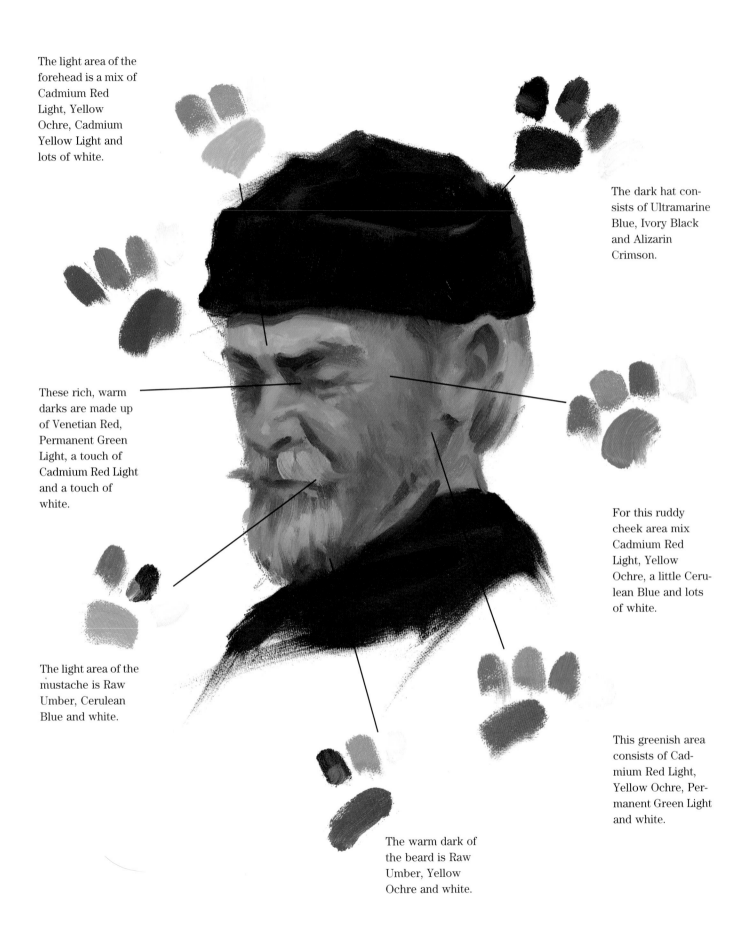

The dark hair is Ivory Black, Cadmium Orange and a little white. The light area of hair is the same mixture as for the dark hair with more white and a little more Cadmium Orange added.

The light forehead area is a mix of Burnt Umber, Alizarin Crimson and white.

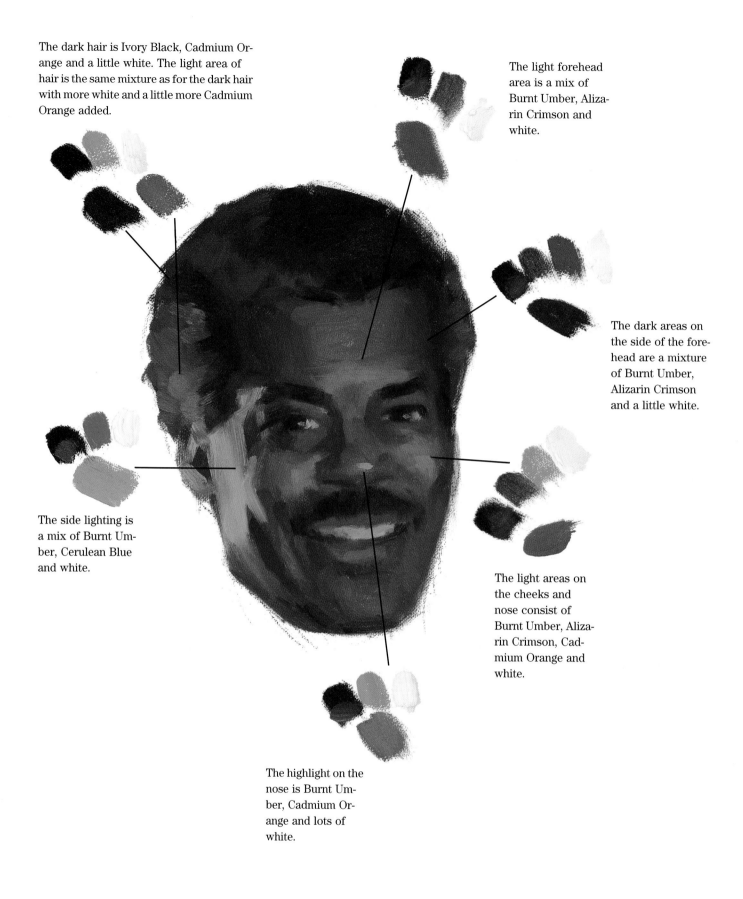

The dark areas on the side of the forehead are a mixture of Burnt Umber, Alizarin Crimson and a little white.

The side lighting is a mix of Burnt Umber, Cerulean Blue and white.

The light areas on the cheeks and nose consist of Burnt Umber, Alizarin Crimson, Cadmium Orange and white.

The highlight on the nose is Burnt Umber, Cadmium Orange and lots of white.

For the light forehead area, a mix of Cadmium Orange, Cadmium Yellow Light, Raw Sienna and lots of white was used.

The light area of the hair is Cadmium Orange, Yellow Ochre and white.

There is a light warm shadow area and the mixture consists of Cadmium Orange, Raw Umber, Yellow Ochre and white.

The middle tone in the hair is made of Cadmium Orange, Burnt Umber, Yellow Ochre and white.

The rosy cheeks are a combination of Cadmium Red Light, Cadmium Orange, Raw Sienna and white.

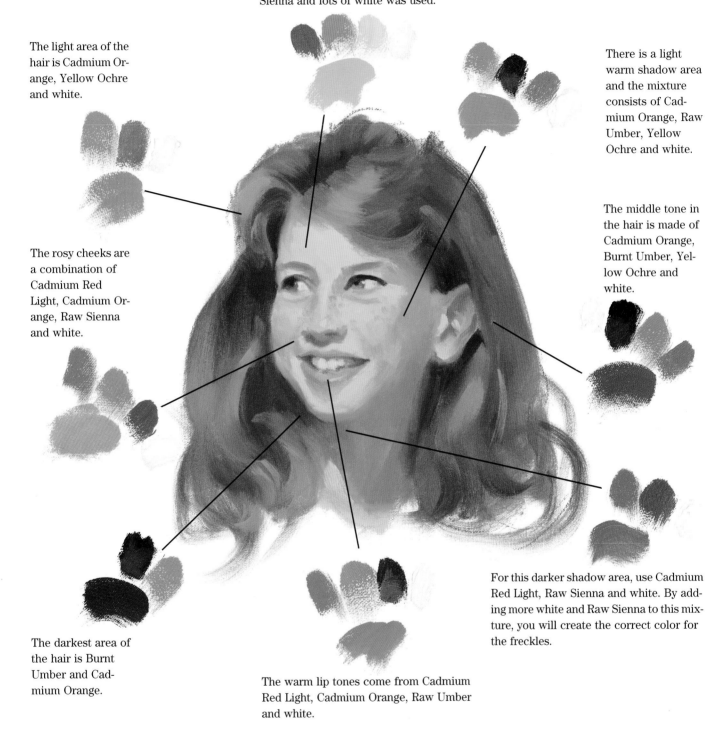

For this darker shadow area, use Cadmium Red Light, Raw Sienna and white. By adding more white and Raw Sienna to this mixture, you will create the correct color for the freckles.

The darkest area of the hair is Burnt Umber and Cadmium Orange.

The warm lip tones come from Cadmium Red Light, Cadmium Orange, Raw Umber and white.

Basics for Drawing and Painting
Figures in Action

The sketchbook habit is the most useful way to develop your drawing skills, powers of observation and selection processes. Not only that, it really is terrific fun. As your drawing improves, it will become an even more enjoyable pastime. It will become a vital part of your life, and a sketchbook will be another item among your basic personal effects, like a purse or a wallet. Don't leave home without it!

CHOOSING SKETCHING TOOLS

It all comes down to personal preference. You can try technical pens, markers, graphite pencils, fountain pens, ballpoints, sharpened sticks and inks, carbon pencils, colored pencils or whatever. The tool is not important. What *is* important is that you feel comfortable with whichever instrument you are using.

As an example, you can work with lightfast, waterproof marker pens. Carry a small pouch containing pens of differing line widths, from 0.1mm through 0.8mm. Include one black water-soluble marker; if you wish to record a pattern of values you can lick a finger and smudge the ink for a halftone effect.

There are so many different sketchbook sizes and formats that you'll have no problem finding one that suits you perfectly. Spiral-bound books do not tend to lose their leaves over the years.

Sketchbooks that record your travels become like diaries. It's a good idea to make little notations about the date, weather, names and any bit of trivia that occurs to you while you are in the area. Later, when you open to that page, the memories will come flooding back, and you will be able to paint from that sketch with all the feeling that originally prompted you to draw it.

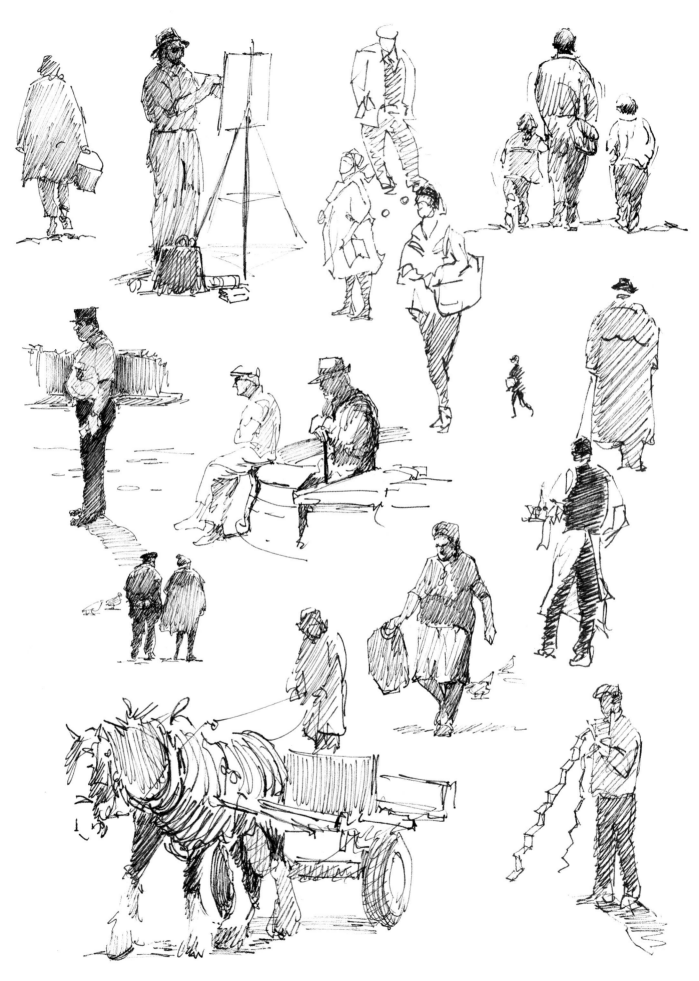

Drawing With Your Brush

A wonderful way to loosen up before a drawing session is to begin with one- and two-minute poses. You may be surprised by what you can put down on paper in such a short period of time. Then move on to five- and ten-minute poses. Use a brush to do all the drawing, generally a no. 6 or no. 8 sable round. It is difficult to get tight when drawing with a brush during short poses. Finish the sitting with a twenty-five-minute pose. Even during this period use your brush to draw. Begin with a light value such as Raw Sienna and, as the drawing progresses, use more intense color.

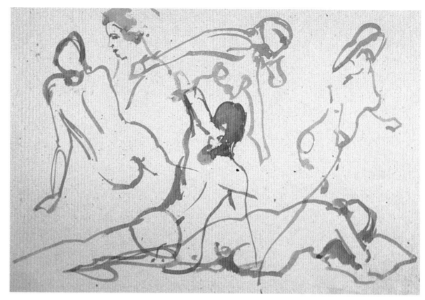

These one-minute poses were drawn with a brush. The goal was to capture the essence of the pose with a flowing line.

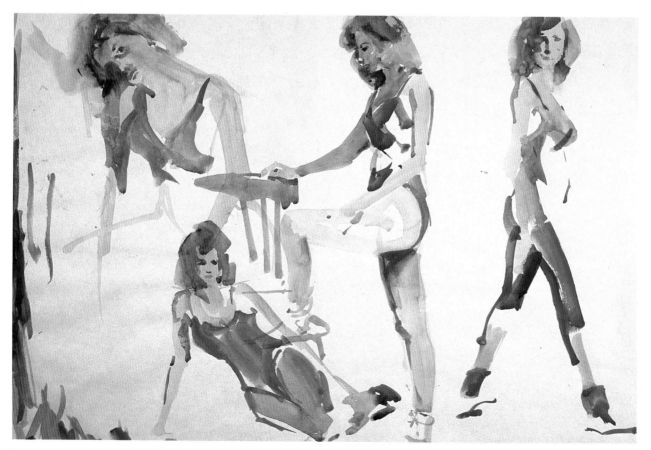

Ten-minute poses allow much more time. In this series, the artist not only drew the figure with the brush but also had enough time to add some skin and clothing color. White areas indicate the light source.

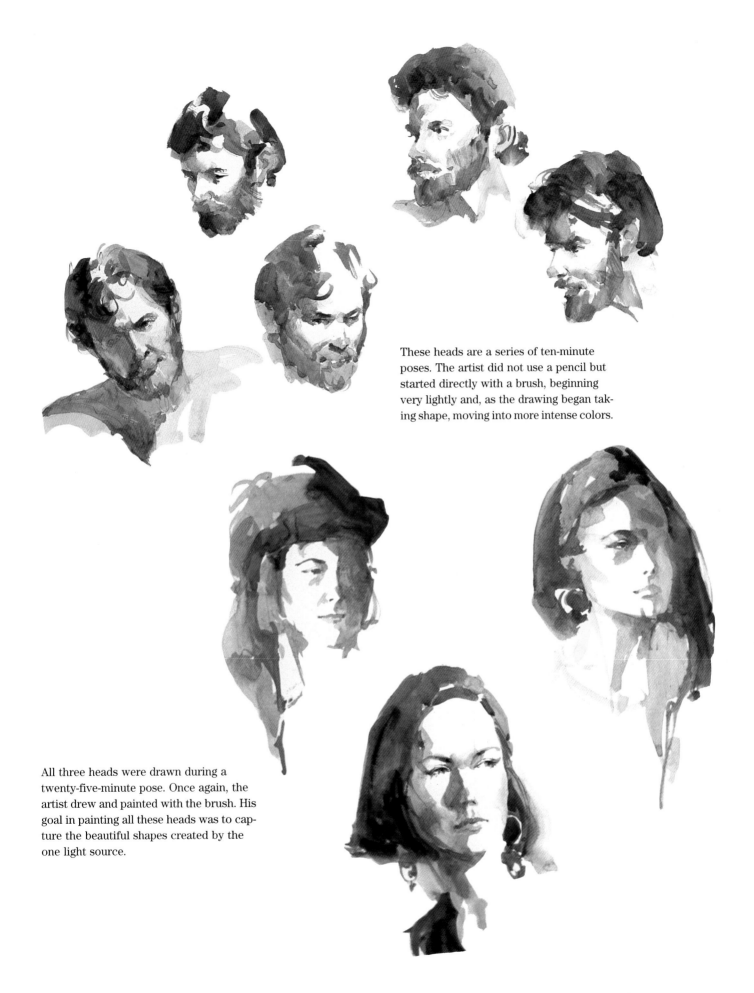

These heads are a series of ten-minute poses. The artist did not use a pencil but started directly with a brush, beginning very lightly and, as the drawing began taking shape, moving into more intense colors.

All three heads were drawn during a twenty-five-minute pose. Once again, the artist drew and painted with the brush. His goal in painting all these heads was to capture the beautiful shapes created by the one light source.

Putting Figures Into Your Paintings

How many times have you seen a landscape, cityscape or seascape that, though well painted, seemed to be missing something? The missing ingredient in such a painting is often people! The scene looks deserted. Of course, not every painting needs figures to make it complete, but most scenes are improved by the addition of even one figure—especially if that figure, however small and simply indicated, looks convincing and seems to fit into the scene. Adding appropriate figures to your paintings will do at least two things: (1) give scale to the scene, and (2) help make the scene seem alive. Figures, by the way they are attired or by their pose or action, help your painting show such things as weather, time of day or season, and can act as centers of interest.

Lots of careful observation in drawing from live subjects, learning from your mistakes and studying the work of past masters—these are ways to become proficient at painting figures. However, following are some relatively easy ways to indicate smaller or incidental figures in your work, such as the two shown in the painting to the right.

When you're painting on location and want to include some of the people you see in the scene, you can be sure none of them will be staying in one pose very long. Try to capture the pose you like with a very quick gesture sketch to record the general proportion and attitude of the figure. Practice helps. The sequence below shows how to go from a gesture sketch to small, finished figures.

Basic shapes of the figures are quickly sketched to indicate the attitude or gesture.

Next, these shapes are filled in with body, clothing and hair shapes, indicated simply.

Last, figures are painted as simple shapes, then a few shadows and details are added.

(at right)
TOM HILL
Old Italian Hill Town
Watercolor, 29" × 21" (74cm × 53cm)

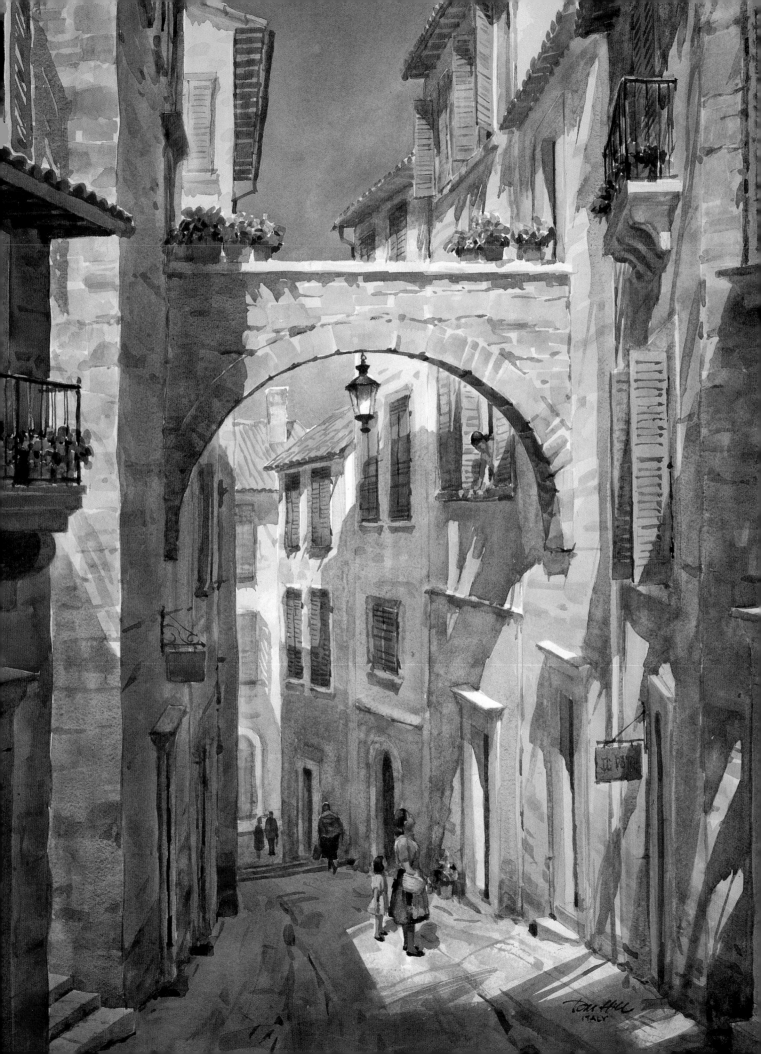

From Gesture Sketch to Finished Figure

For a painter, there's no substitute for the years of drawing and painting that bring knowledge and expertise, especially when drawing or painting large representational figures. Still, many artists learn to draw and paint convincing smaller figures in a fairly short period of time—figures that seem to fit into the scene and not look wooden or contrived. On these pages are some examples that may be helpful, especially if you are painting on location and have to work from what you see before you.

Although the typical stick figure looks stiff and mechanical, keeping a bare-bones skeleton in mind as you do your quick gesture sketch can be very helpful. Your simplified skeletal-gesture sketch should try to account for three major shapes: the head, the rib cage and the pelvic bones, or hips. The various angles that these elements take, plus the lines of the spine, legs and arms, go a long way toward establishing a correct framework upon which you can "hang" the flesh, hair and clothing.

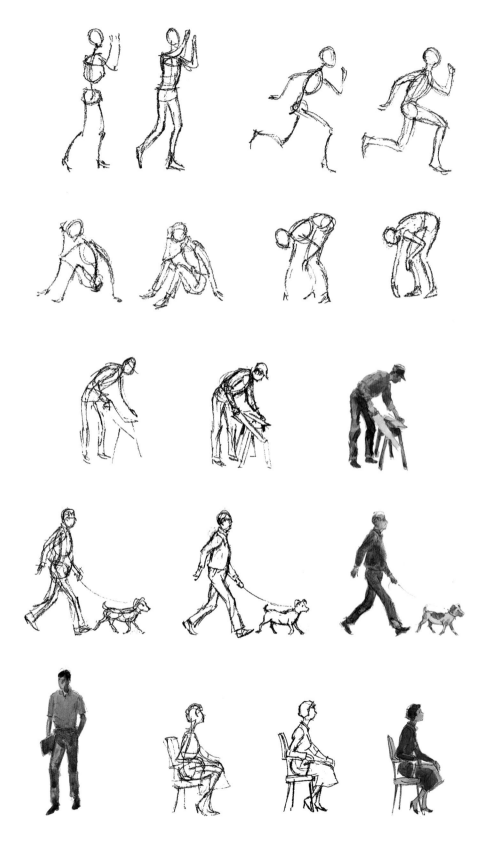

Study the figure sketches here, as they go from quick gesture sketch to final color application. Note how lines used for spines, arms and legs are never straight, but curved. Details on small figures like these are not needed, and would probably detract from the rest of your painting.

Don't expect perfection immediately. You learn by looking, practicing, seeing your own mistakes and overcoming them. Soon, you'll be painting figures while on location even *after* your model has left the scene!

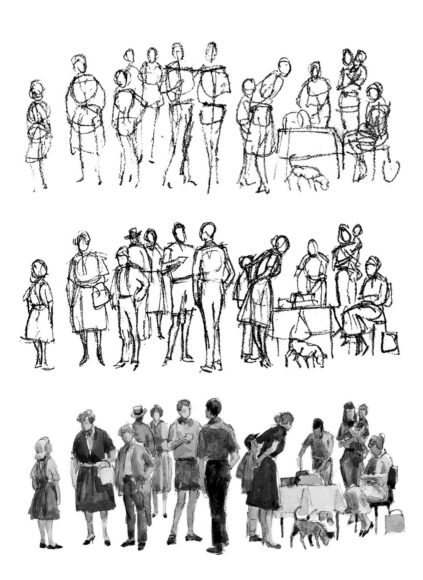

Painting an Island Market

As you can see in the photo below, the market was loaded with exciting colors, shapes and plenty of figures—great subject matter for any artist! Setting up your easel in a place with so much activity probably isn't feasible for most painters. When you encounter a scene like this one, bring out your sketchbook. Record what you see and retreat to a place where you can design your composition. You will take the chaos of a market scene like this one and convert it into a well-designed, visually exciting painting that, though edited and rearranged, still conveys all the charm and feeling of the market but in a less confusing way.

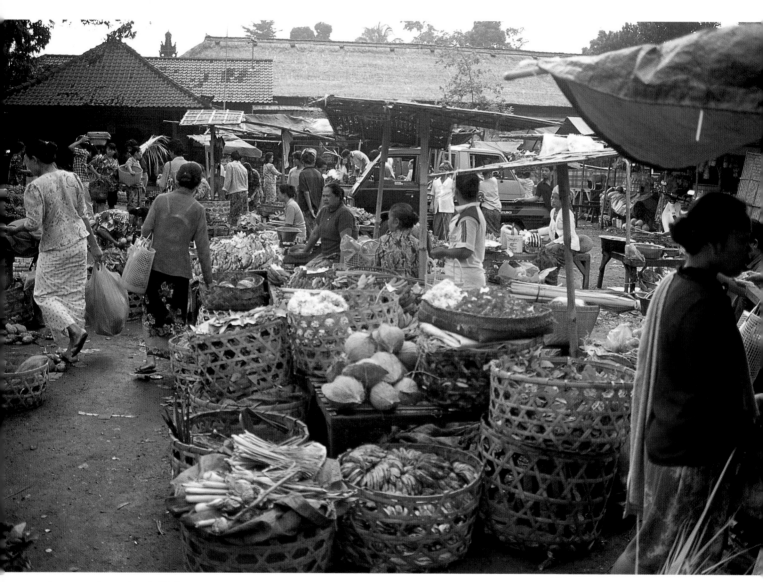

An open-air market in Bali.

On this page are some of the sketches used in making the painting. To the right is the rough compositional design which was about the size of a postcard.

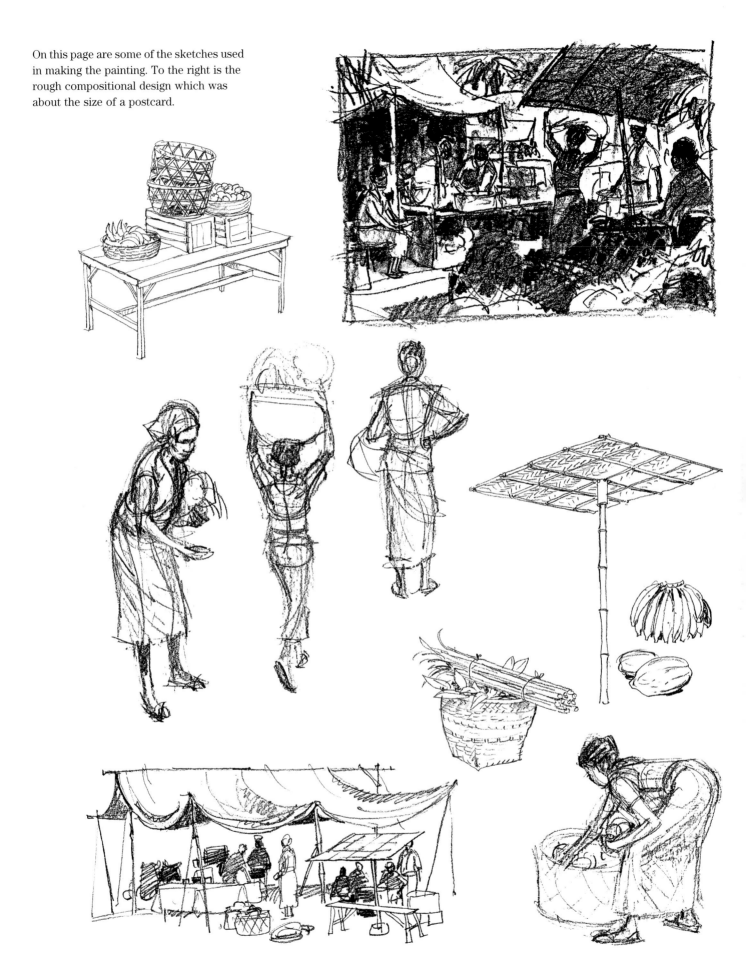

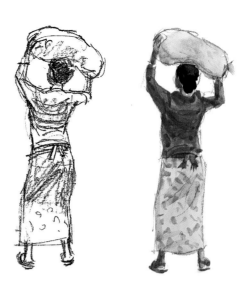

With practice, you'll soon be able to catch a lot of information in a quick gesture sketch. The artist had only a few seconds to make his first rough sketch of this lady as she moved through the mar-

ket. But as he watched, she repeated this same basic pose as she walked. By continuing to observe her, he was able to further refine his drawing.

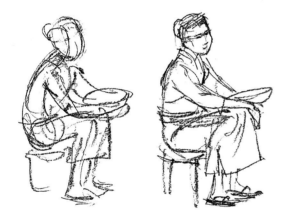

This young lady was seated and not moving much. Still, the artist's first sketch was rapidly done to be sure he captured the essence before she stood up. As time passed, he had a chance to study the

stressed and relaxed areas of her clothing. The folds and drapes of material were determined by her body position and were important to making a convincing finished figure.

The artist used this fellow in the painting, changing his position slightly, but still working from the drawing made in the market. There is a suggestion of features in his face, but *only* a suggestion,

for too much more would be out of keeping with the rest of the painting.

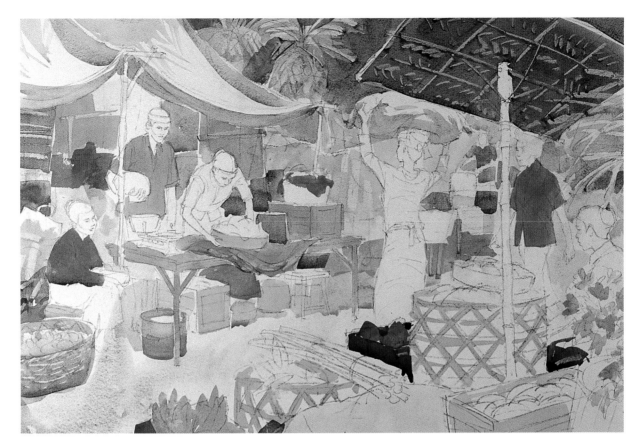

1 Using the value and composition study shown on page 61 and his sketches made in the market, the artist pencilled in the drawing. He started laying in mostly flat washes of the various items and shapes using both flat and round watercolor brushes.

Note that there are very few complicated color mixtures: The sky is Cobalt and Manganese Blue, the bamboo shade is Burnt Sienna with bits of Raw Sienna and most of the other color areas are equally simple combinations.

DETAIL He lightened some areas by squeegeeing or scraping the color out while the paint was still quite moist—in the bamboo shade and the foliage, for example.

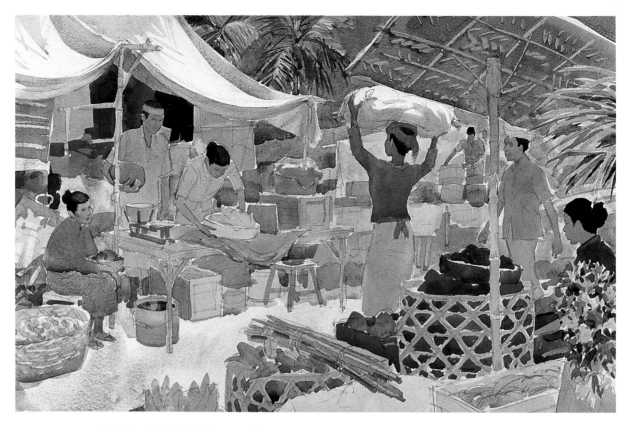

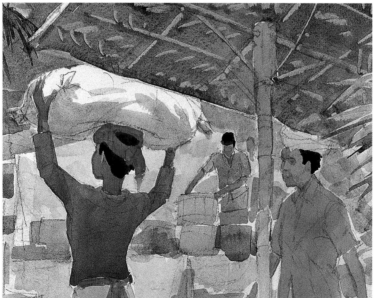

DETAIL Note how the bag on the woman's head is largely defined by the bamboo's shade, the blue sky and the arms, hands and turbaned head of the figure.

2 The artist continued the color application, still using the larger flat and round brushes and working mostly in flat patterns. He was also thinking about how to best define the forms other than by their shape alone. A lot of this was accomplished by the changes in color and value from one shape to the next: dark value against light, warm color against cool, intense color against grayed color, etc. Good examples of this are found in the way the man is defined by the fabrics behind him and, in the foreground, the weave of the large basket by the darks within it.

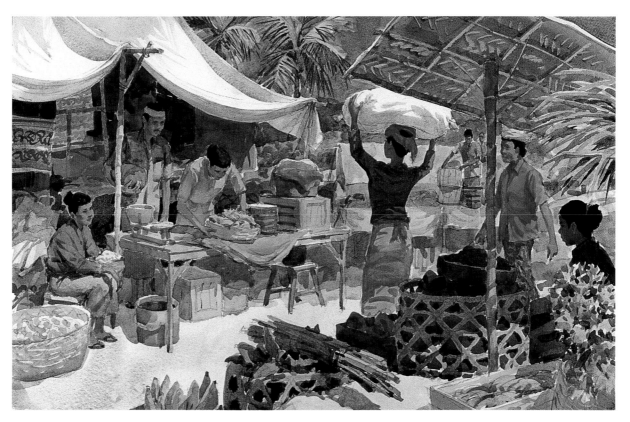

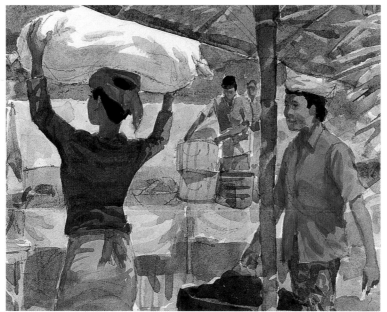

3 Next, as shown above, he painted in a lot of the shadows, helping to give more form to objects and creating a feeling of sunshine. He applied transparent glazes over many of the areas under the white awning and under the bamboo shade. (A glaze is a wash of color painted over already painted dry areas.) These glazes, being darker in value, helped "pull together" those areas, separating them from lighter areas in front of them and creating a feeling of depth.

How should you mix the colors in a shadow? Take more of the same color that is already on the object, add a little of its complementary color, plus a bit of whatever other color is being reflected into the shadow. If the proportions are right, it works!

DETAIL Look at the red-violet blouse of the woman carrying the bag on her head. To make the shadow color, the artist simply mixed more of the red-violet, added just a touch of its complement (yellow-green), plus some blue to account for the reflected light from the sky.

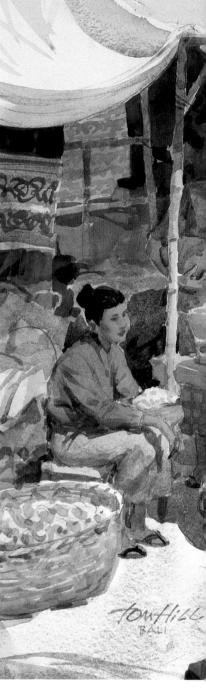

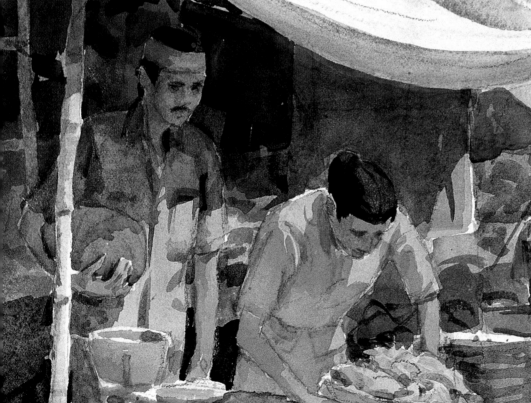

TOM HILL
Balinese Market
Watercolor

DETAILS OF FINISHED PAINTING

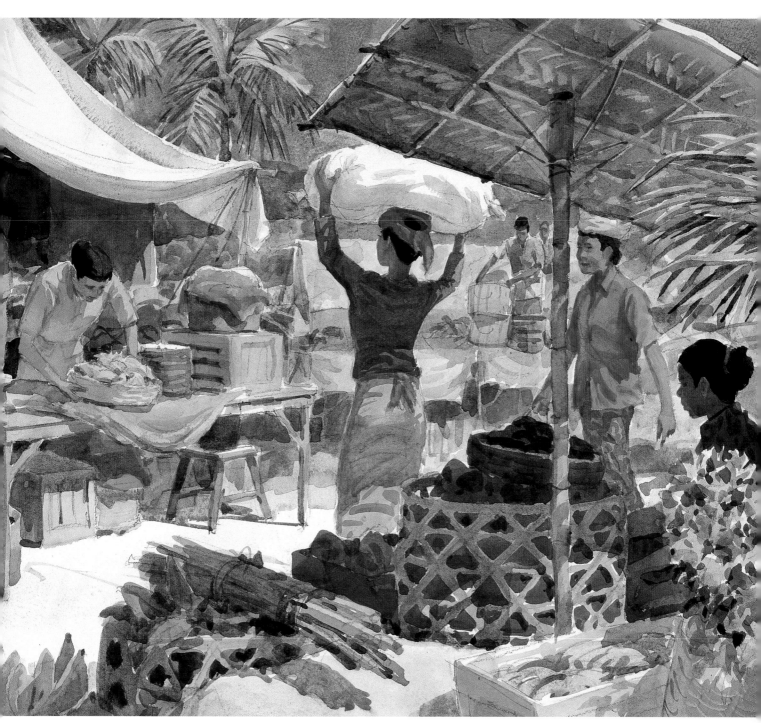

4 Here is the finished watercolor, not very different from the stage shown on page 65, for all the basics were already established: drawing, design, colors and values, the "feeling" of the painting. All the artist needed to do to finish the painting was add a few details, adjust one or two color and value relationships and look it over for obvious mistakes or things that were forgotten.

From Sketch to Finished Painting

1 This is a sketchbook drawing with minimal lines. The artist, Robert Wade, took about five minutes for this drawing.

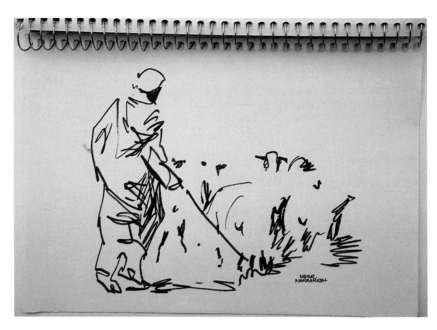

2 A few preliminary drawings were done on scrap paper, and when the artist envisioned the result, he began the drawing, trying desperately not to lose its simplicity. The first wash of Raw Umber and Winsor Violet went over the whole surface except where highlights were reserved. No masking here.

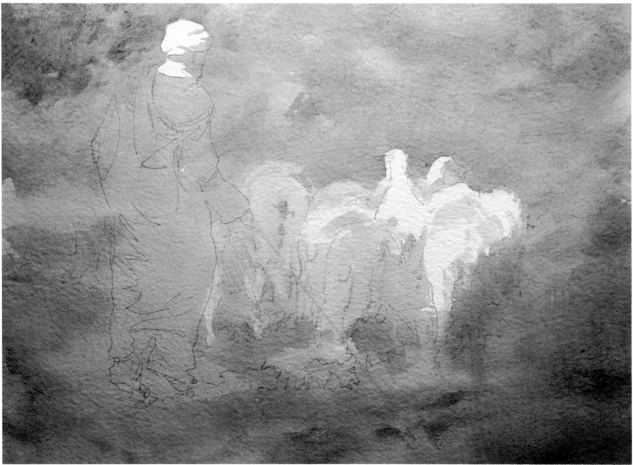

Even the quickest sketches can be transposed into a full-sheet watercolor. The artist used no masking in this process. He likes to prove to himself that the brush is under his command.

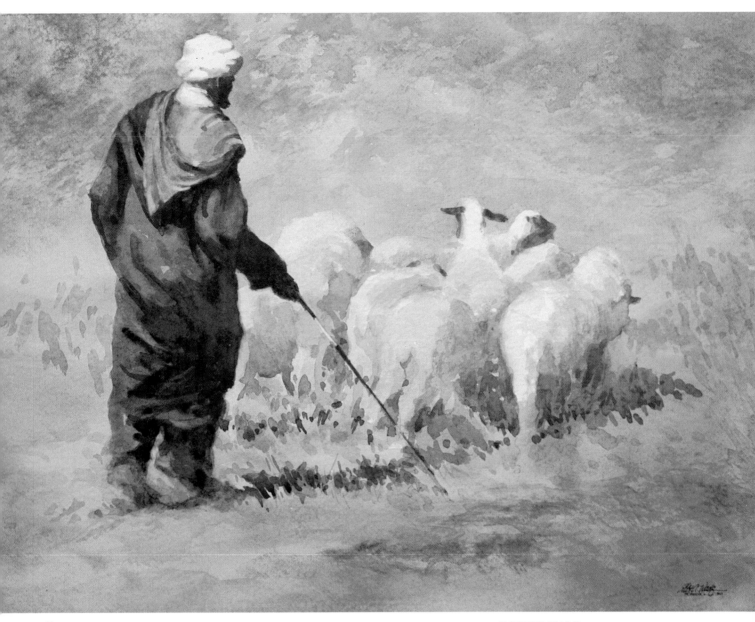

3 Not much was needed to carry the image through—some background texturing, contouring of the shepherd's cloak and some colorful shadows around the white shapes to trick the eye into believing they are sheep.

ROBERT WADE
The Shepherd, Morocco
Watercolor, 20"×30" (51cm×76cm)

Painting a Crowd

Here's the Djemaa el Fna, Marrakesh, where it's possible to buy anything from secondhand false teeth to a mummy's shroud. The artist found a place on a hotel roof where he was allowed to sketch, providing he purchased a cola every ten minutes (at five times the usual price!), so he made it a quick drawing.

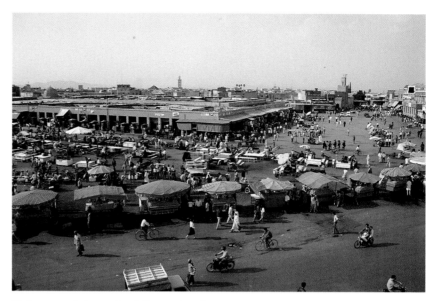

Reference photograph of the marketplace.

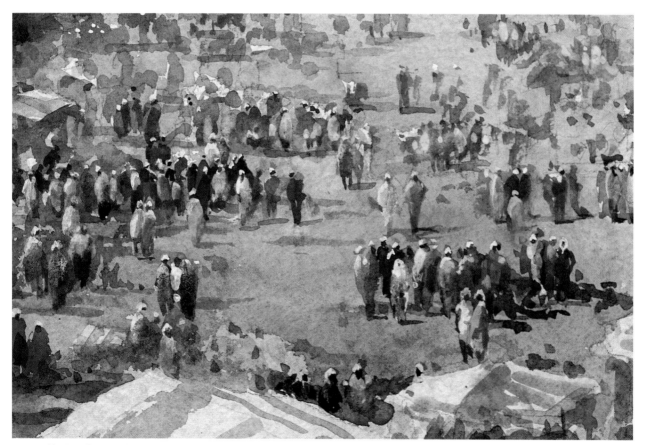

DETAIL Notice the simple indefinite blobs in the background and increasing detail in the foreground. The artist used gouache to dash in the headgear and some highlights on the many scattered figures.

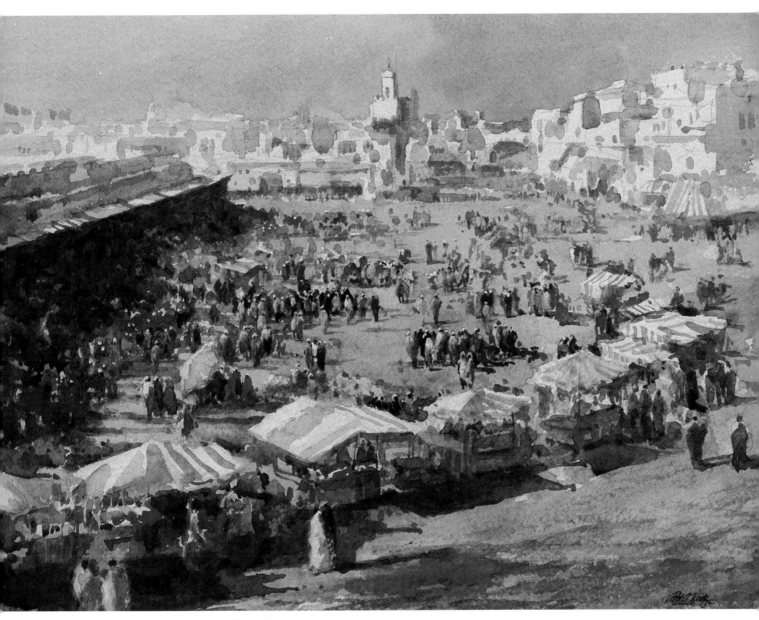

An overall initial wash of Aureolin and Rose Madder Genuine sets the warm feeling. When glazed over in Cobalt Blue, the underpainting shines through with the impression of warmth. Notice the color of the shadows on the buildings.

Visual Awareness

It is incumbent on us, the visually aware, to help others appreciate and see the beauty that surrounds us wherever we are. Even in an office or store, a shaft of light falling on a typewriter could make a pattern of light and shade so wondrous it would take one's breath away. A wet wintry day brings remarks about how miserable everything looks and hopes for tomorrow's weather to improve, yet to the visually aware it means something quite different. Winter is a beautiful season, a time when the landscape is having its face washed by Mother Nature . . . gentle rain softens harsh outlines, disguises otherwise ugly shapes and structures, and brings beauty to squalid and unattractive areas. Can't you just see those puddles and reflections?

This is where the very soul of a painting is born and becomes apparent to its creator, long before a pencil or brush is ever put to paper. It's a consciousness that slowly grows with the artist as he or she delves beneath the surface, feels the mood, selectively disposes of areas that are incompatible with the mood that is materializing, and finally settles on an interpretation and an understanding of the subject that has evolved from this soul-searching examination.

Caught in day-to-day activities, these subjects from around the world are examples of the artist "seeing the painting" in the ordinary pursuits of people.

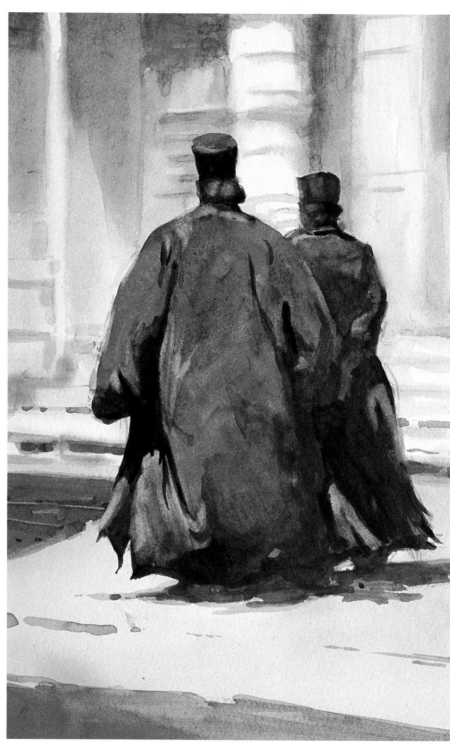

ROBERT WADE
The Priests, Jerusalem
Watercolor, 14" × 10" (36cm × 25cm)

Can you feel the billowing of those voluminous robes? Careful observation allowed the artist to convey that flowing movement. Note the joined shapes.

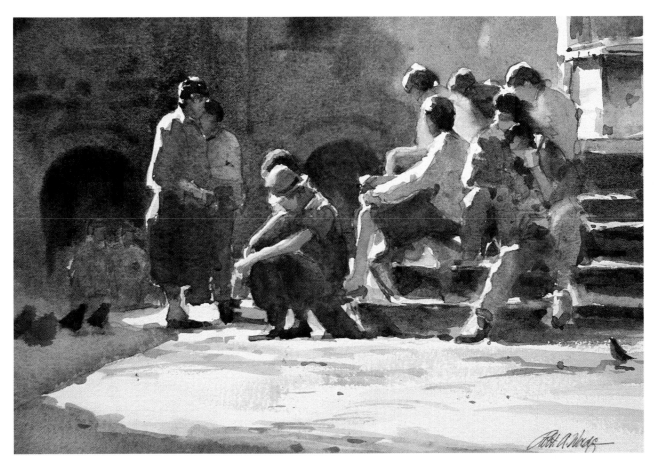

ROBERT WADE
San Gimignano Steps
Watercolor, 11″×14″ (28cm×36cm)

There's a real sparkle in this subject which
could have been very ordinary without the
light passage across the forms and all the
color in the background.

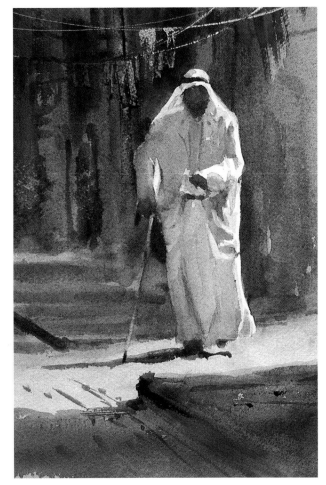

ROBERT WADE
The Arab
Watercolor, 10″×6″ (25cm×15cm)

Again, it's the observation of light and its
effect that makes this little sketch work.

Thinking It Through

Having noted wonderful sights and effects, the next step is to begin the process of creating your painting. The first thing to do is *"See with your brain"*: Observe the highlights, the shadows, the values, and their effect on the overall picture pattern plus their color relationships to one another in the general scheme of things.

Next comes *"Feel with your eyes"*: the investigation of shapes and their form. Feel the bulk, weight, rhythm and movement, and discover the receding or advancing of the various elements. Observe the textures of edges throughout the subject, and become totally aware of your game plan of how you intend to tackle the subject in paint.

By this time all the information has been fed into your mental computer, which will allow you to *"Interpret with your heart."* You can now make this assessment of the mood and atmosphere so that you will be able to paint the *feel* of your selected subject.

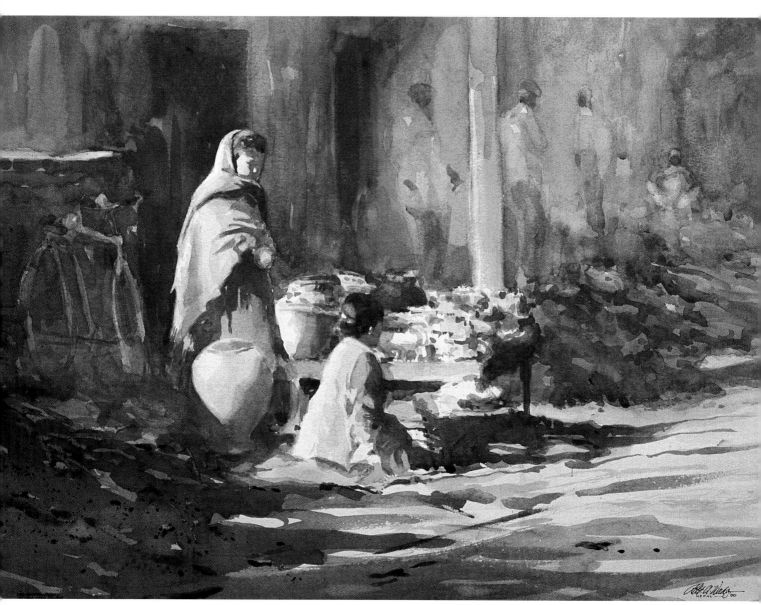

ROBERT WADE
The Potter's Stand
Watercolor, 14"×20" (36cm×51cm)

This subject demonstrates the importance of light passage through a painting. Note its path very carefully, seeing where it falls across forms and how the rounded pots and figures catch, hold and then turn away from it.

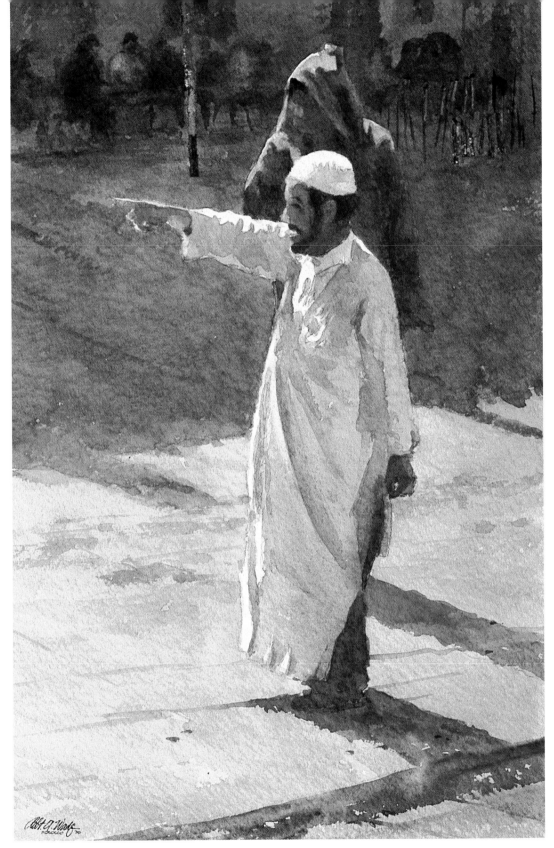

ROBERT WADE
That Way to the Souk
Watercolor, 20" × 15" (51cm × 38cm)

This is a case of glazing cool over warm to create a tremendous color vibration. Aureolin and Rose Madder Genuine went over the whole painting except for the highlights reserved on the foreground figure. Cool washes were then applied over that warm wash, and you can see the effect it gave. The figures in the background café give a good impression of depth.

Demonstrations
in Watercolor, Oils, Pastel and Colored Pencil

Seated Figure

AL STINE

Reference photo.

Stine does his own photography for his portrait work in addition to creating several pencil sketches. This provides an opportunity to talk with the models, thus getting to know their personalities—something that can seldom be captured by a camera.

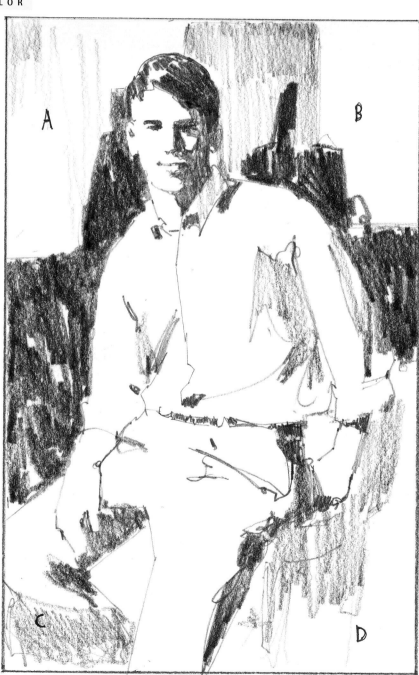

This drawing is based on the cruciform and on alternation: light against dark and dark against light. Each corner—A, B, C and D—is intentionally a different size and shape. This adds variety and interest to the drawing.

1 INITIAL DRAWING

This drawing was done on Arches 140-lb. (300gsm) cold-pressed paper using both a photograph and sketches for reference.

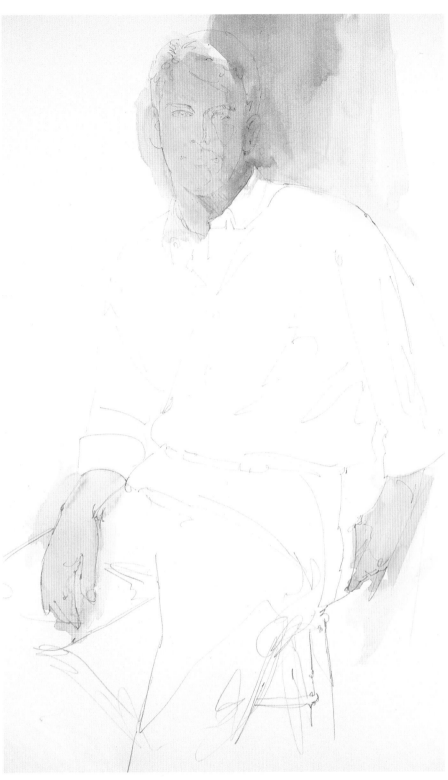

2 BEGIN PAINTING

Begin the painting with a wash of Cerulean Blue. Paint the head with a mixture of Rose Madder Genuine and Aureolin, allowing the colors to mix on the paper rather than on the palette. Use more Rose Madder Genuine in the areas of the cheeks, nose and mouth to warm them up. Also paint the hands using the same colors.

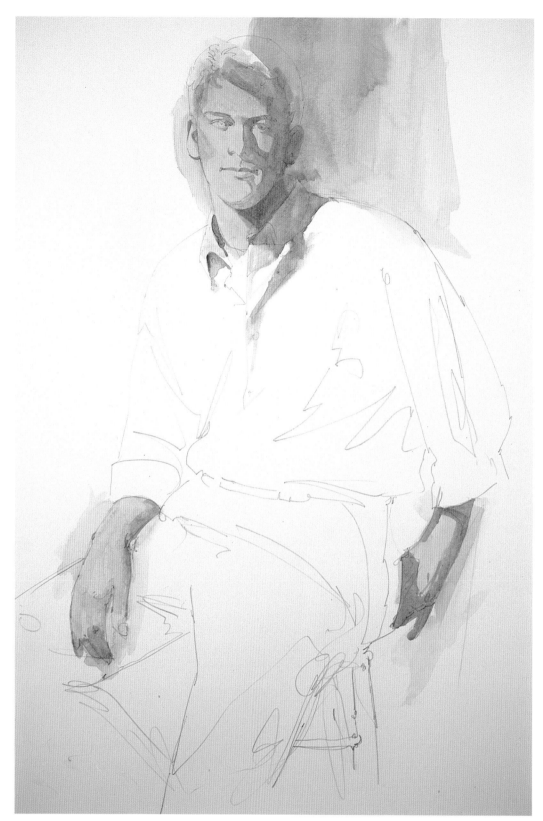

3 START PAINTING SHADOW AREAS

To get the darker value, substitute Yellow Ochre for the Aureolin. When painting the area just below the chin, add a little Cobalt Blue to the mixture for a cooler shadow. Again, use the Cobalt Blue with Yellow Ochre to paint a cool area on the shirt.

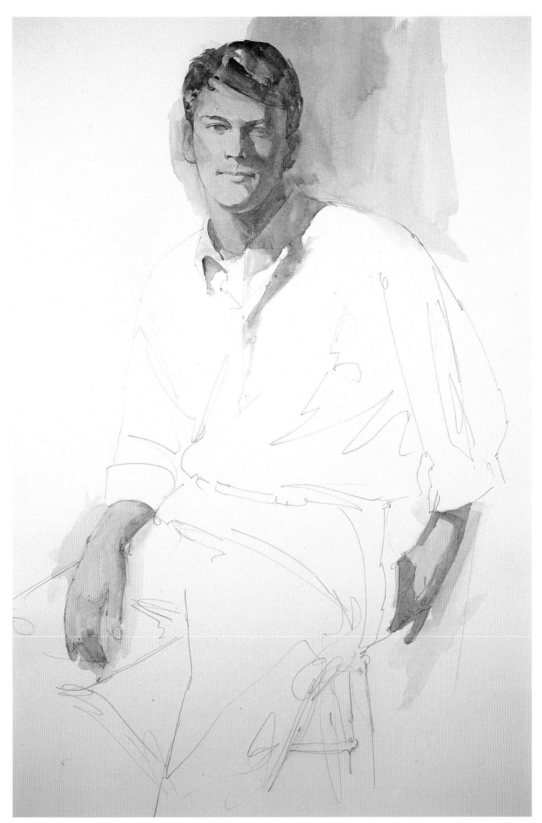

4 DEVELOP HAIR AND FACE
Paint the hair using Rose Madder Genuine, Aureolin and Cobalt Blue. Begin developing the features of the face and carry them to completion.

AL STINE
Scott
Watercolor, 20″ × 13″
(51cm × 33cm)
Collection of Dr. and
Mrs. Carl Geier
Anderson, South
Carolina

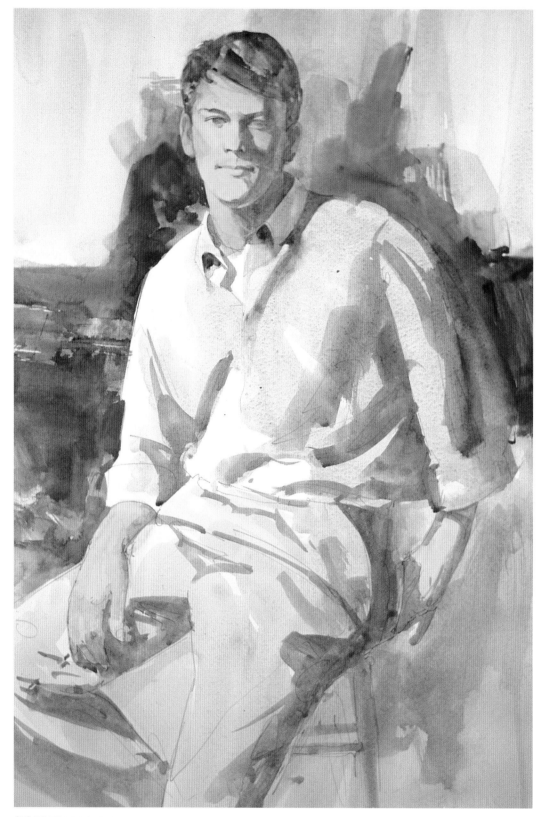

5 FINISH BACKGROUND AND CLOTHING

Emphasize the head by placing darker shapes around it. Finish the clothing and then turn your attention to the background. For the lighter background values use Aureolin and Cobalt Blue. After these washes have thoroughly dried, use deeper values of the same colors for the darker areas. This painting has a fresh quality and the vertical format suits Scott's pose.

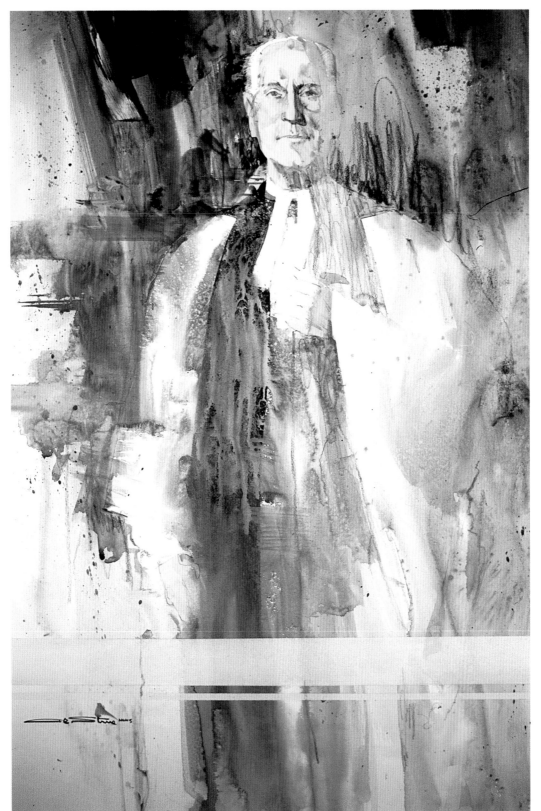

AL STINE
Archdeacon
Watercolor, 28″ × 20″
(71cm × 51cm)
Collection of Mr. and
Mrs. Francis Erck-
mann, Georgia

Like the portrait on the opposite page, this one is also in a vertical format. Stine did this painting several years ago of a friend, a retired archdeacon of the Church of England, who was kind enough to don his vestments and pose. The vertical format shows the long, flowing garments that are so much a part of him.

A Direct Gaze

AL STINE

PALETTE

Basic Colors:
- Permanent Rose
- Raw Sienna
- Cobalt Blue

Incidental Colors:
- Cadmium Red
- Cerulean Blue
- Raw Umber

1 BEGINNING THE FACE
Starting with the eye, work a mixture of Permanent Rose and Raw Sienna down around the nostril and continue to the neck.

2 PAINTING SKIN TONES
Using the same mixture, begin painting at the top of the head, taking the color right up into the hair. Continue the wash down to the neck, allowing the color to mix and mingle on the paper. Warm up the areas around the nose and cheeks with Permanent Rose and a bit of Cadmium Red. Also paint the arms at this stage, allowing the colors to bleed beyond the pencil lines.

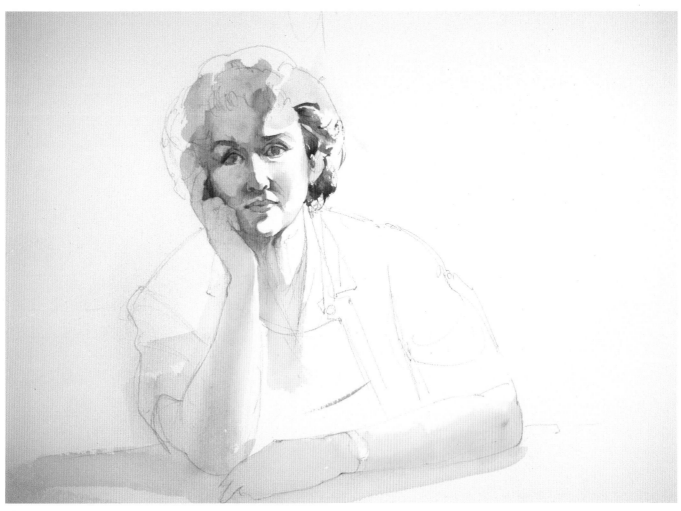

3 WORKING ON THE HEAD
Work on the features, bringing the head almost to completion with the exception of the hair.

4 WORKING ON THE BACKGROUND

Never try to go too far with a figure without doing some work on the background areas. The artist used Cerulean Blue for this wash and charged in a little Raw Sienna, letting the colors mingle.

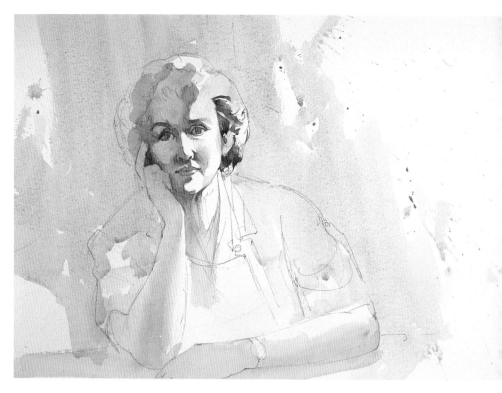

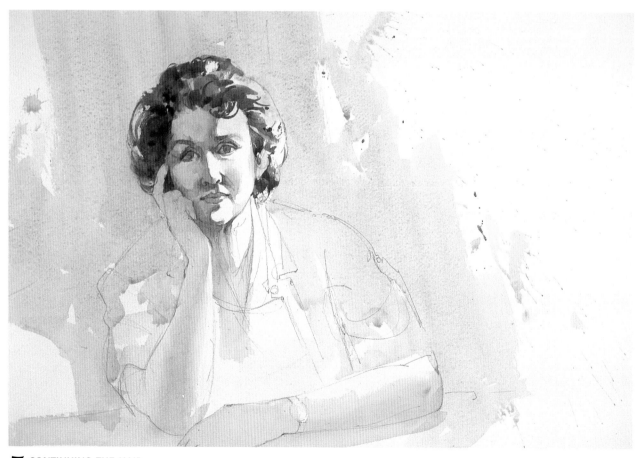

5 CONTINUING THE HAIR

Paint a grayed blue-purple mixture using all three basic colors. For some brush licks, the artist laid a round on its side and dragged it across the paper.

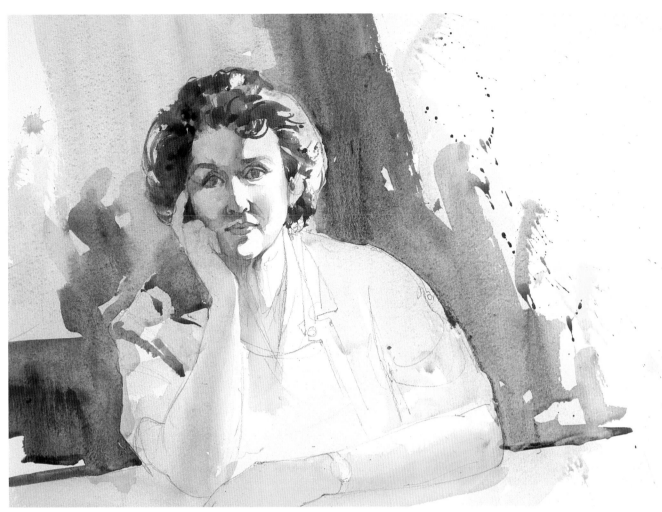

6 MAKING PROGRESS ON THE BACKGROUND AND SHADOWS

Paint a deeper value into the background using Cobalt Blue and mingle in some Raw Sienna, which defines the highlighted area of the hair, shoulder and arm. To the left of the figure use the same Cobalt Blue mixture to indicate the shadow being cast on her shoulder, losing the edge into the background. At the bottom, hold the shape of the table with the same color.

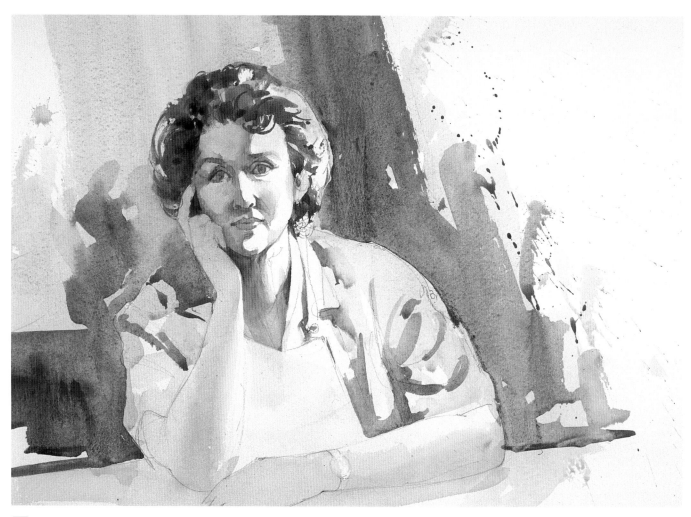

7 PAINTING THE DRESS
Indicate some folds using the same
Cobalt Blue mixture.

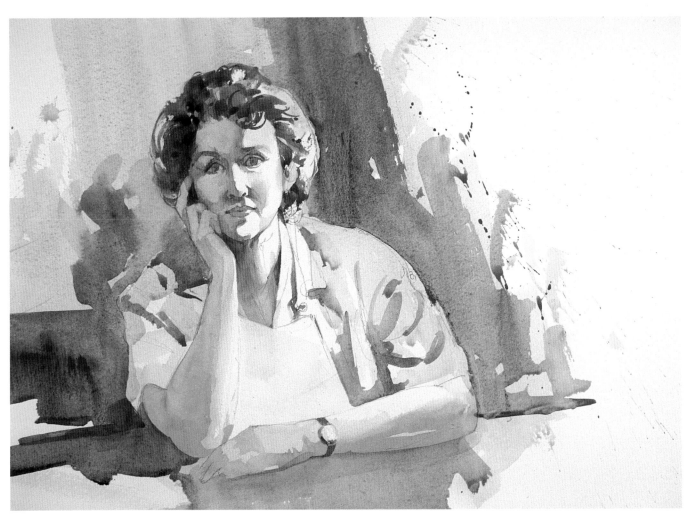

8 DEVELOPING THE ARMS, HANDS AND TABLETOP

While the next wash is still wet on the arms, use a Cobalt Blue mixture to create a shadow on the tabletop in order to hold the shape of the arms. This allows the flesh color to bleed into the blue, giving a better transition along with a reflective quality on the tabletop.

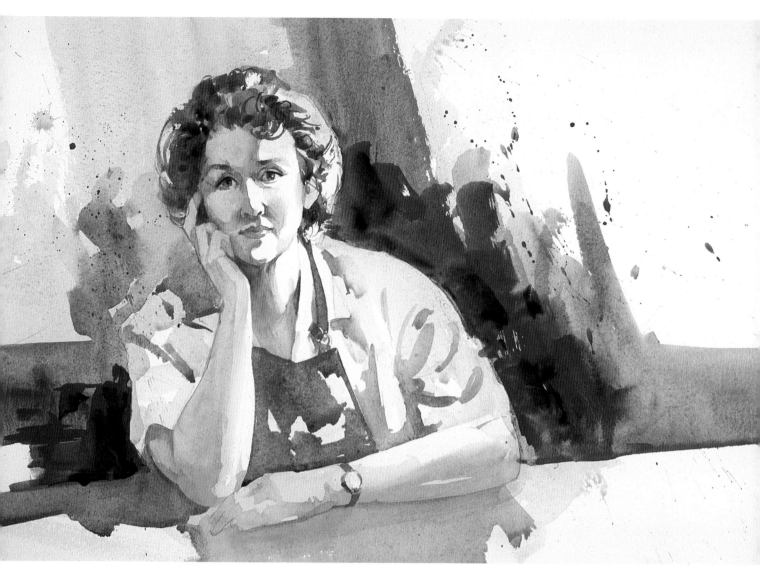

AL STINE
Sallie
Watercolor, 13"×20" (33cm×51cm)

9 FINISHING TOUCHES

Extend the background shape to the right of the figure, which gives a better division of space. Intensify the value in this area and on the left, making the figure stand out a little more. This also makes the lights appear lighter. Note that the vignette has a different shape at each of the four corners of the paper, and carrying the white of the vignette into the figure helps to better relate the figure to the background.

Next, paint the apron and its strap with Cobalt Blue. While it is still wet, mingle in some Raw Umber to gray it, creating a color different from that in the background. Add more detail to the eyes and use a razor blade to scratch out the highlights of the pupils. And finally, add more darks in the hair to complete the painting.

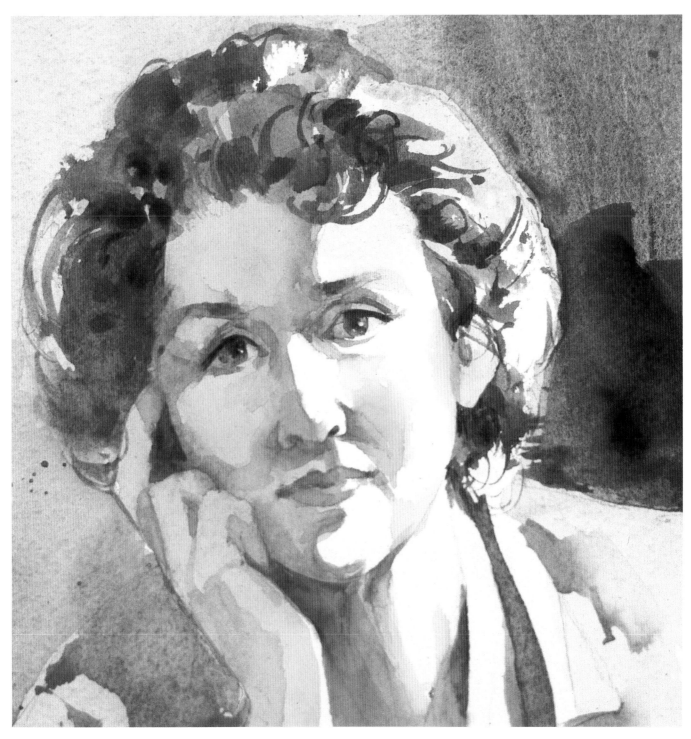

Close-up of the face.

People in Sunlight

MICHAEL P. ROCCO

Michael Rocco came upon this scene while on a short vacation to Jamaica. Walking through areas not meant for tourists and visiting markets, back streets, and isolated beaches with twisted tropical trees, he came upon these fishermen in a small village. With their permission, Rocco photographed them, thanked them and continued his exploration. The experience made an impression and he has painted several pieces from that excursion.

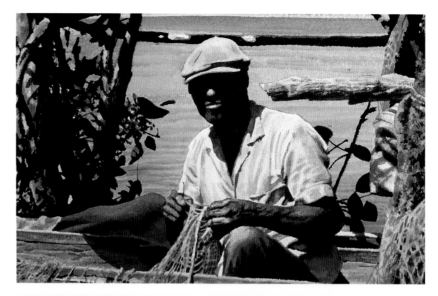

DETAIL OF SUNLIT MAN

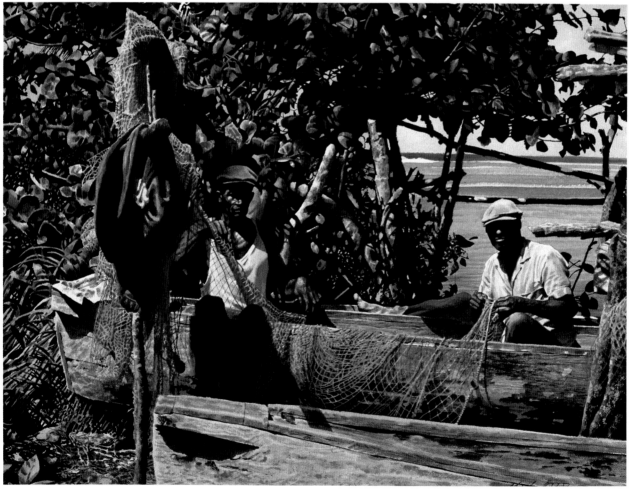

MICHAEL P. ROCCO
Mending the Nets
Watercolor, 18"×23" (46cm×58cm)

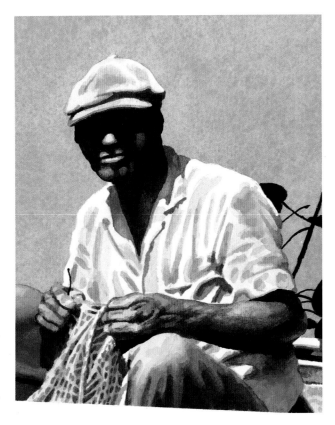

1 PUT IN FIRST WASHES

Paint a simplified background first by premixing ample color, then outlining a portion of the contour using a no. 2 brush, filling the area with a larger brush as you go. In this way, you keep the color flowing and do not allow any section to dry, thus finishing with an even wash. After this dries, paint pale washes in the shirt, cap and trousers, then add deeper color to the shirt for shadows and reflected light.

2 PAINT LIGHTER TONES

Put in the light shadows of creases in the shirt and cap and folds in the net. Blend color into the trousers, keeping the faded look at the knee. Begin constructing the head by painting the prominent highlights of the features, adding color to the cheeks, chin and neck. Paint light tones in the hands and forearm, blending in indications of shadow.

3 PAINT DARKS AND DETAILS

Develop the shirt's creases with deeper values, and put in the shadow near the neck. (Note the reflected light.) Paint the shadow on the head and neck with a dark wash, working around previously painted areas, then blend this color softly into the highlights with intermediate colors using the point of a no. 2 brush. Model the form of the hands and forearm using colors to capture the glistening skin. Accentuate veins and muscles to indicate this man's laborious life.

Farmhand, Circa 1860

MICHAEL P. ROCCO

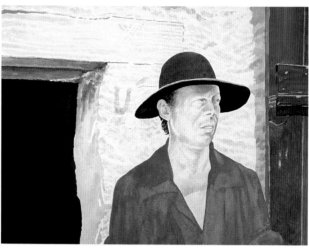

1 ESTABLISH WALL AND DOORWAY AREAS

With a no. 12 round brush, give the wall a roughly scrubbed wash of pale color (leave the figure clear). On the lintel, however, follow the grain of the whitewashed wood. Establish the wall's thickness by adding shadows to its return. Drybrush additional tones onto the wall, developing the stucco. Paint the light colors of the seam, crossboard and knots on the shutter. Then paint the overall colors, avoiding those previously painted sections. In the doorway area, dampen the paper then apply the dark color using just enough water to make it flow properly.

2 BEGIN PAINTING THE FIGURE

Paint the farmhand's head and neck in an initial fleshtone. Add in the crown of the hat and follow this with the blue of the shirt. Allow each of these areas to dry between coverages. Next, start forming the features of the head and neck with deeper fleshtones. Add shadows, folds and creases to the shirt and wash away some of its color, giving softness to the material. Paint the underside of the brim, bringing this color down into his hair.

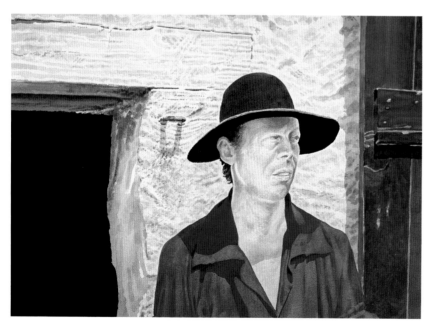

3 ADD TEXTURE AND SHADOWS

Add more detail to the stucco wall, accentuating its irregular surface with drybrush texture and light-value shadows. Treat the lintel in the same manner and delineate its outline further. Strengthen shadows and texture on the doorway wall. Deepen the shadows of the folds of the shirt and on the shoulders. Using the point of a no. 2 round brush, shade the crown of the hat for form and texture.

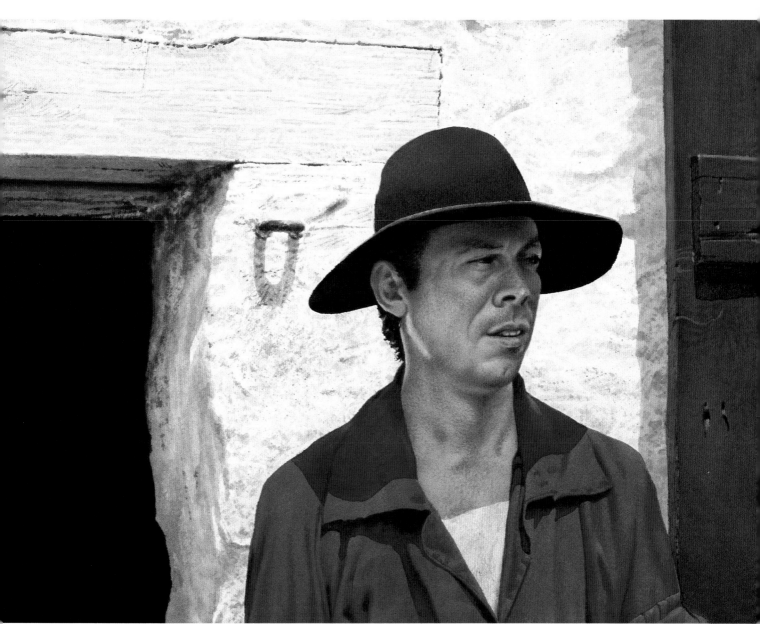

4 WORK ON FINISHING THE HEAD

Begin modeling the head using the same brush and technique as on the hat. This gives the porous look of the skin. Work on the head as a unit, structuring its overall form. Bring fleshtones down in value to put the head in shadow, yet retain reflected light which is so important to the contours. As you paint, think as a sculptor—three-dimensionally. Structure the features slowly, feeling the pull of muscle and bone. Deepen the value of the forehead, making it recede softly into the hat. If you feel the shutter commands too much attention, you can bring its value down.

MICHAEL P. ROCCO
Farmhand, Circa 1860
Watercolor, 17" × 23" (43cm × 58cm)

PALETTE

- Lemon Yellow
- Cerulean Blue
- Yellow Ochre
- Raw Umber
- Cadmium Red
- Alizarin Crimson
- Payne's Gray
- Neutral Tint

Figure Study

KEVIN D. MACPHERSON

Figure studies are good practice exercises for seeing various color and value relationships between different combinations of clothes, accessories, backgrounds, hair and skin tones.

The Big Shapes
Do not paint the features. Paint the big shapes. Do not think separate objects. The ear, face and neck are all one interlocking shape.

1 THE MODEL
It is best to have your model dress in simple colors. Establish an obvious light-and-shade pattern with a strong light source, such as a spotlight. Don't let overhead lights or windows diffuse your shadow patterns too much. This photograph is a good exposure of the light family, but not the shadow family. Notice how dark and colorless the shadows are. It doesn't show the colors the eye can usually see in shadows. However, it does indicate the overall shadow pattern well.

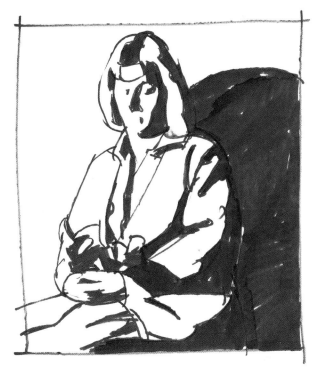

2 THE MODEL OUT OF FOCUS
Squint to see the shadow pattern and the largest, most important shapes. This out-of-focus photograph reduces the major shapes to their most obvious color notes.

3 BLACK-AND-WHITE SKETCH
Organize your pattern of light and shade with a black-and-white sketch, indicating all the shadow areas in solid black with a marker. This will separate your light family from your shadow family and show their relationships, which you will retain in the color study. If you make this sketch directly on your painting surface, you can paint right on top of it. However, the black marker will bleed through in time, so this is not recommended for serious paintings.

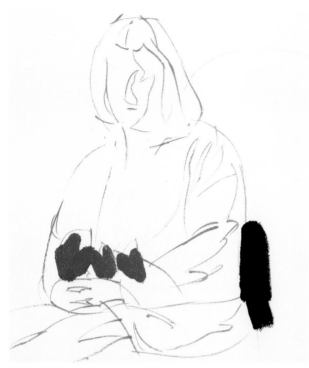

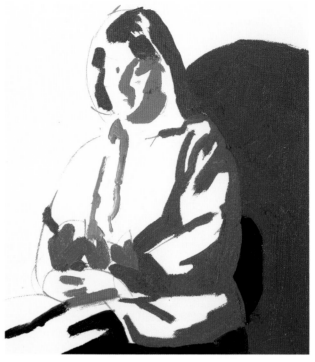

4 ESTABLISH EXTREMES
Work on a white canvas because it is easier to judge accurate relationships. Establish the lightest light, darkest dark and easiest color.

5 ESTABLISH MAJOR SHADOWS
Establish the major shadow shapes in living colors. Do not look for details and small shapes too soon.

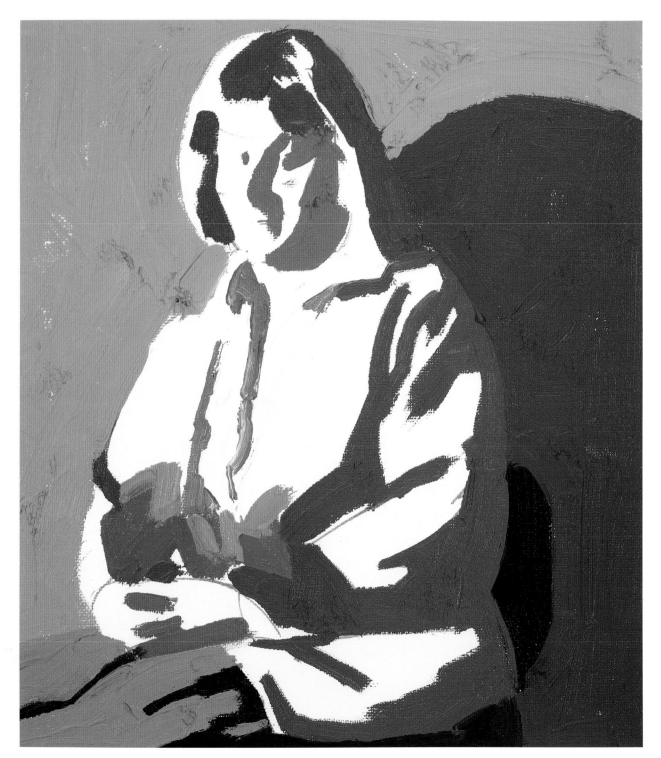

6 THE LIGHT FAMILY: BACKGROUND AND SKIRT

The background color is just as important as the head or shirt because it has a relationship with the subject. As you begin painting the light family, reshape your shallow shapes negatively (as in the thin shapes on the blue skirt).

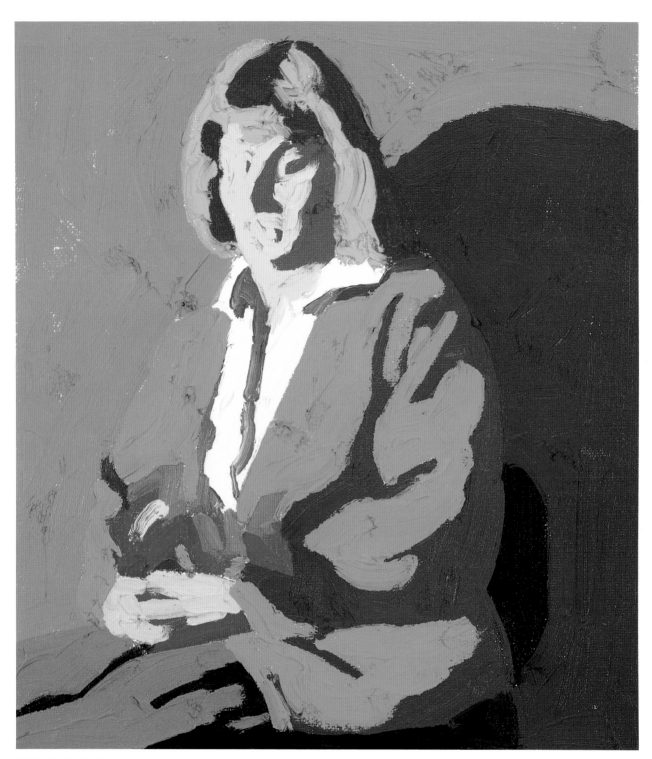

7 A FINISHED START

The figure is just an arrangement of shapes, colors, light and shade accurately placed. This is a good start.

KEYING YOUR PAINTING

The lightest light and the darkest dark set the value range and key of your painting. The key of a painting is like the key of a piece of music; you can play a song in the key of C or the key of E, but it is still the same music, just higher or lower. Painting is similar; you can start your painting warmer, cooler, lighter or darker. It's up to you. When painting in a high key (light), you need to establish your darkest dark much lighter than it appears. In a low-key (dark) painting, the lightest light will be darker. Your value range will probably be narrower in a high- or low-key painting, but the same principles of relationships are applied.

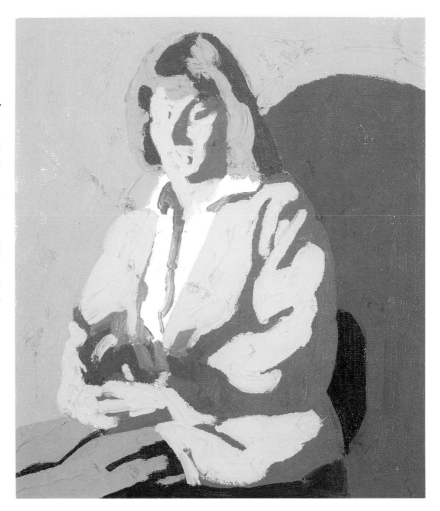

Black and White Values
Notice the values in this black-and-white reproduction of a good start. If the color is correct, the values will be correct because color has an inherent value.

The Color Notes
Sometimes the change from one color note to another is only slightly lighter, darker, warmer or cooler. Notice that all the shadow colors are darker than the light colors. Making correct color choices from the start ensures the rest of the painting will go smoothly. A wrong note will pop out, so change it right away.

Korean Girl

PAUL LEVEILLE

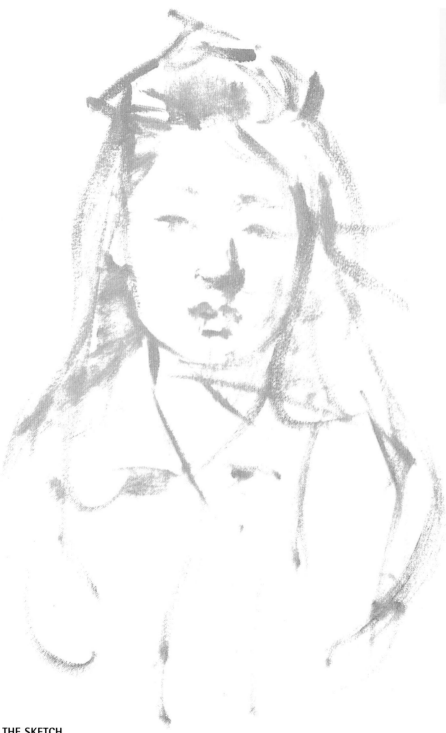

When sketching with paint it is very easy to make corrections. Simply dip a portion of paper towel in turpentine, then wipe away undesired paint strokes. Now you're ready to start fresh.

1 THE SKETCH

With a more spontaneous approach, start this portrait of a young girl by sketching directly with paint on white canvas. With a no. 8 filbert, apply a light purple mixture of Ultramarine Blue, Alizarin Crimson, white and a touch of Cadmium Red Light. Begin with brush strokes at the top of the head and chin to indicate the position of the head on the canvas. Next, add vertical strokes to indicate the sides of the head, followed by the feature guidelines and shoulders.

2 THE BASIC SKIN TONE

To cover the white canvas, scumble a mixture of Burnt Sienna, Yellow Ochre, Cadmium Red Light and white over the face, arms and some of the background using a no. 10 filbert. Use very little medium with your paint at this point. Too much medium will cause the paint to be slippery, making it difficult for additional layers of paint to adhere to the canvas.

Apply a darker value of the same mixture (less white) to the upper forehead. To achieve the light areas of the forehead and cheeks, use a clean paper towel to wipe some of the paint away. Add a little pink to the cheeks and nose using a mixture of Cadmium Red Light, Burnt Sienna, Yellow Ochre and white.

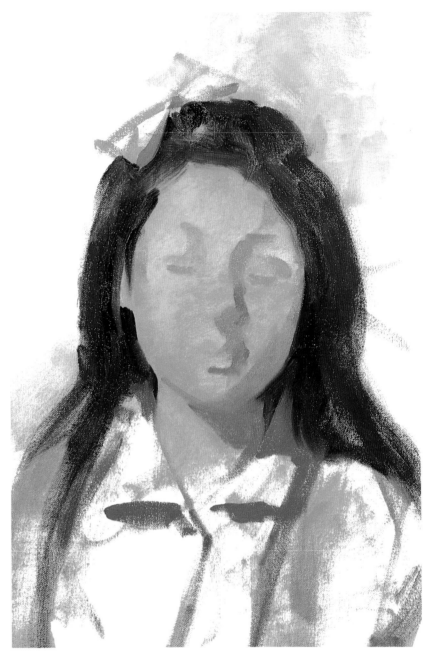

3 THE DARKS

By squinting at the model, you will be able to eliminate all the subtle value changes and view the shadow areas as simple dark shapes. Use a mixture of Cadmium Red Light, Ultramarine Blue and white for the shadow shapes along the cheek, nose and lips. The shadows for the lighter areas of the upper side of the nose and cheek are warmed up by adding Cadmium Orange to the mixture.

Use a no. 10 filbert for the large dark shapes of the hair using a mixture of Burnt Umber and Ultramarine Blue. The warm halftones are a mixture of Burnt Umber, Cadmium Red Light, Yellow Ochre and white. For the cool shadows on the blouse, use Alizarin Crimson, Ultramarine Blue and white.

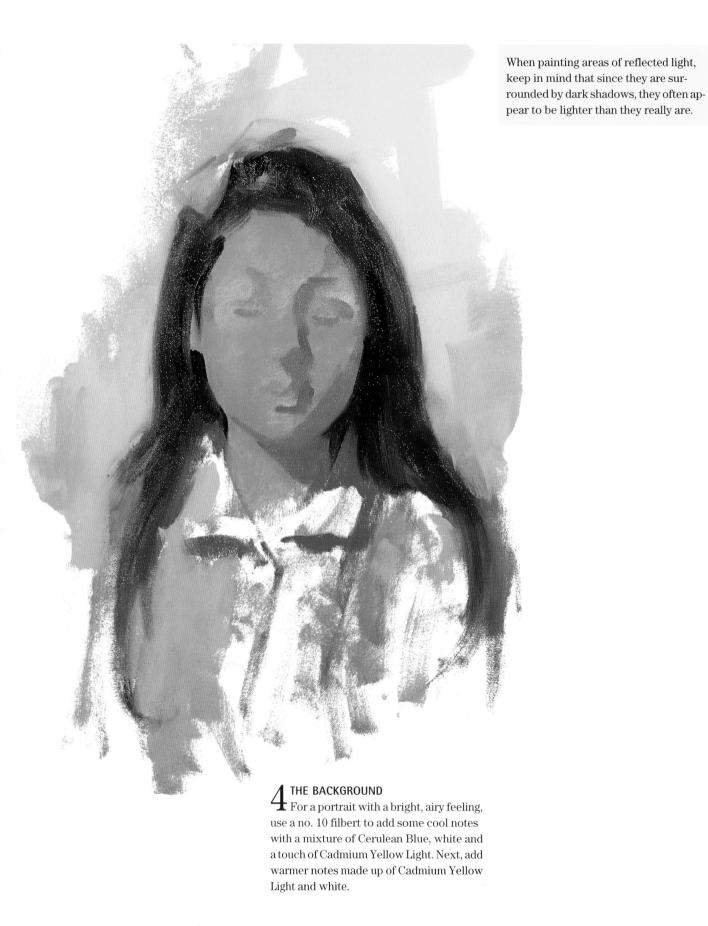

When painting areas of reflected light, keep in mind that since they are surrounded by dark shadows, they often appear to be lighter than they really are.

4 THE BACKGROUND

For a portrait with a bright, airy feeling, use a no. 10 filbert to add some cool notes with a mixture of Cerulean Blue, white and a touch of Cadmium Yellow Light. Next, add warmer notes made up of Cadmium Yellow Light and white.

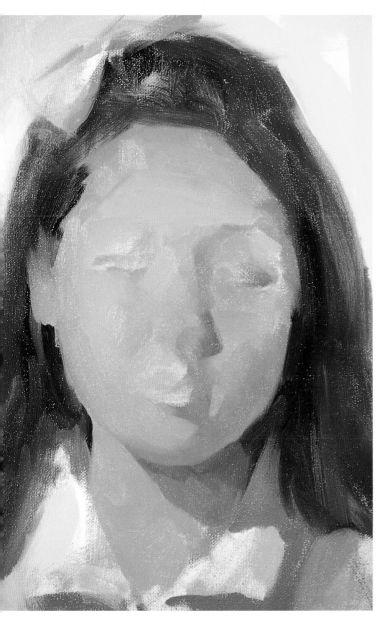

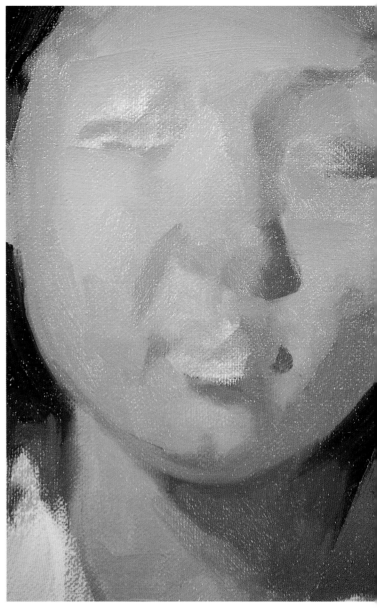

5 THE SHADOWS

Darken the neck shadow using Venetian Red, Ultramarine Blue, Cadmium Red Light and white. For the chin and lower cheek cast in shadow, add a mixture of Venetian Red, Yellow Ochre, Cadmium Orange and white. Paint a warmer tone of Cadmium Red Light, Venetian Red, Yellow Ochre and white on the cheeks and nose. On the light side of the face, paint the chin with a warm tone of Raw Sienna, Cadmium Red Light and white. Use variations of this mixture on the cheek and forehead.

6 THE MOUTH AREA

Build form in this area by painting subtle halftones of Raw Sienna, Cadmium Red Light, Cadmium Orange and white. Add reflected light under the chin by using Yellow Ochre, Venetian Red and white.

7 THE LIPS

After the mouth area is shaped through values and color, start on the lips. Paint the overall shapes of both lips with a no. 6 filbert using a mixture of Cadmium Red Light, Cadmium Orange and white. Mix a slightly darker mixture of Cadmium Red Light, Raw Umber, a touch of Alizarin Crimson and white for parts of the upper and lower lips. The side of the lower lip and corners receive a warm dark mixture of Cadmium Red Light, Alizarin Crimson, Raw Umber and white. Redefine the shadow under the lower lip using Raw Sienna, Venetian Red and a touch of white.

8 FINISHING THE LIPS

Finally, paint the warm dark area between the lips with Burnt Umber and Cadmium Red Light. Add highlights by using a mixture of white, Cadmium Red Light and Cadmium Orange.

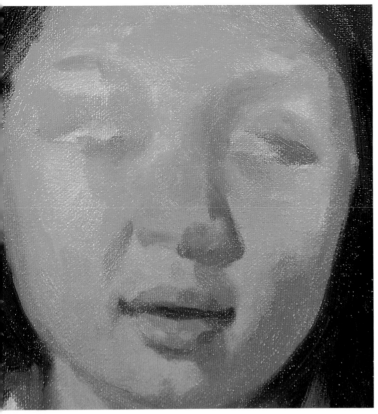

9 THE NOSE

Once again, start by painting the larger shapes first. Paint light halftone shapes around the nose area using a mixture of Cadmium Red Light, Burnt Sienna, Raw Sienna and white. For dark shapes under the nose, add more Cadmium Red Light and Burnt Sienna to the mixture. This mixture, with some variations, works well for other areas of the face including around the eyes and forehead. Also use it to soften the shadows on the upper portion of the nose and eyebrow.

Redefine the strong shadow on the side and under the nose using Ultramarine Blue, Alizarin Crimson and white. In areas where the shadow receives more light, warm the shadow mixture by adding a touch of Cadmium Orange. Apply a mixture of Cadmium Red Light, Burnt Sienna, Raw Sienna and white to the bridge of the nose. Notice how the artist moved the stroke across the bridge of the nose rather than down. This adds more interest to the painting.

10 FINISHING THE NOSE

The nostrils are painted with a warm dark mixture of Burnt Umber and Cadmium Red Light. The dark nostril area on the light side of the face is warmer because light is penetrating the wing of the nostril. The nostril on the shadow side is darker and has more Burnt Umber in the mixture. Add the highlights on the nose using a mixture of Yellow Ochre, Cadmium Red Light and lots of white.

11 **THE LIGHTS**
Moving up, add halftones to the cheeks using a mixture of Burnt Sienna, Cadmium Red Light, Yellow Ochre and white. At this point, paint the side lighting on the model's left cheek with a mixture of white, Cadmium Red Light and Cadmium Yellow Light. For the light areas of the model's right cheek and forehead, use a mixture of Cadmium Red Light, Yellow Ochre and white.

12 **THE EYES**
Use various mixtures of Cadmium Red Light, Raw Sienna and white to build the forms around the eyes. Paint the dark irises using a mixture of Burnt Umber and a touch of Cadmium Orange, and the upper lashes with solid Burnt Umber. Add a little Venetian Red to Burnt Umber for the upper lash nearest the nose of the model's right eye. The eyebrows are light, so paint them with a mixture of Burnt Sienna, Raw Umber and white.

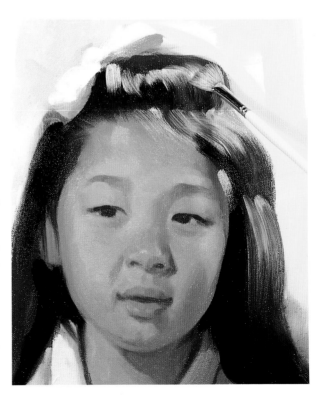

14 **THE HALFTONES IN THE HAIR**
The next large shapes in the hair are warm halftones made up of Burnt Umber, Cadmium Orange and white.

13 **REDEFINING THE SHADOWS**
Moving down to the blouse, redefine this area with a mixture of white, Cadmium Yellow Light and a touch of Yellow Ochre. Warm up the shadows with a mixture of Alizarin Crimson, Cerulean Blue, white and a touch of Burnt Umber. Redefine the large dark areas of hair using a mixture of Burnt Umber and Ivory Black.

15 **THE HIGHLIGHTS**
Add the highlights next. Using a no. 8 filbert, paint on the mixture of white, Cadmium Yellow Light and Alizarin Crimson one stroke at a time. Make only one stroke on the canvas, then return the brush to your palette for fresh paint. More than one stroke will start to mix other colors on the canvas, ultimately turning the colors to mud.

Once all the highlights have been applied, use a fan brush to blend the darks with the highlights. Clean the fan brush with turpentine between strokes.

16 FINISHING UP

View the bow as two shapes—dark and light. Start by painting the light shape with a mixture of white, Alizarin Crimson and Cerulean Blue. Brush in the dark shadows of the bow with a mixture of Alizarin Crimson, Burnt Umber and white.

Because the upper portions of each iris are in shadow from the upper lid, darken them with solid Burnt Umber.

The mouth area needs more darks. Paint the space between the lips with a warm dark mixture of Burnt Umber and Cadmium Red Light. Also darken the shadow on the lower lip with Cadmium Red Light, Raw Umber and white.

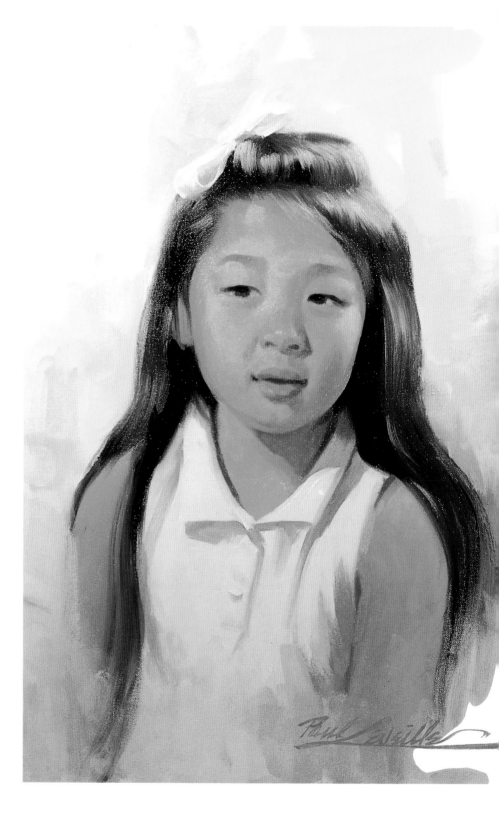

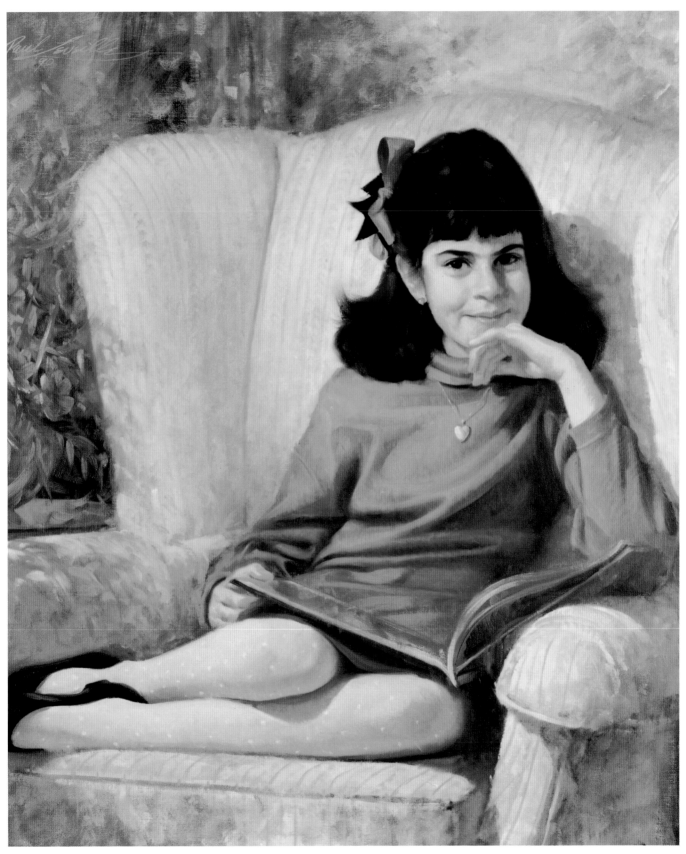

PAUL LEVEILLE
Elizabeth Leveille
Oils, 31″×29″ (79cm×74cm)

This subject, like the one on the opposite page, has dark hair. Notice the difference in complexion.

Color Shapes

KAY POLK

Polk is concerned with only two lines when developing a face—the center line and the expression line of the mouth. Aside from those, the entire portrait is developed with shapes. Polk places the main shapes first and then gradually refines them until the likeness becomes apparent. Start with shapes, then shapes within shapes.

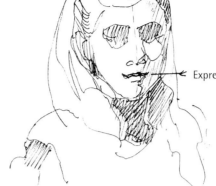

Center line

Expression line of mouth

1 PREPARE THE SURFACE AND BEGIN BLOCKING IN

Kay Polk painted with pastel on linen glued to a Masonite panel. The linen was sealed with two coats of rabbitskin glue which works as a resist so that the first colors go on slowly. She used rags, stumps, paper towels and fingers to rub the pigment into the fabric.

2 BUILD UP SHAPES AND COLOR

Because of the resistant ground, Polk was able to build up shapes and colors slowly. With portraits, shapes are primary. Capturing a likeness is simply a matter of refining the shapes and the relationships between the shapes.

3 REVISE AND REFINE THE IMAGE

Apply color, wipe it off, apply more color and so on. Because of the gradual buildup of pigment, the image will seem to grow out of the canvas. This will allow you time to revise and refine as you work.

4 VALUE AND COLOR TEMPERATURE

By now the color will begin to take shape. Concentrate on value and color temperature as well as on hue. It is especially the value that gives three-dimensional form to the face and figure.

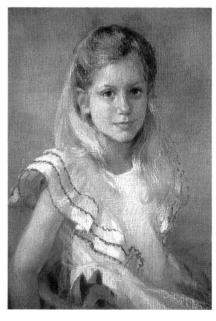

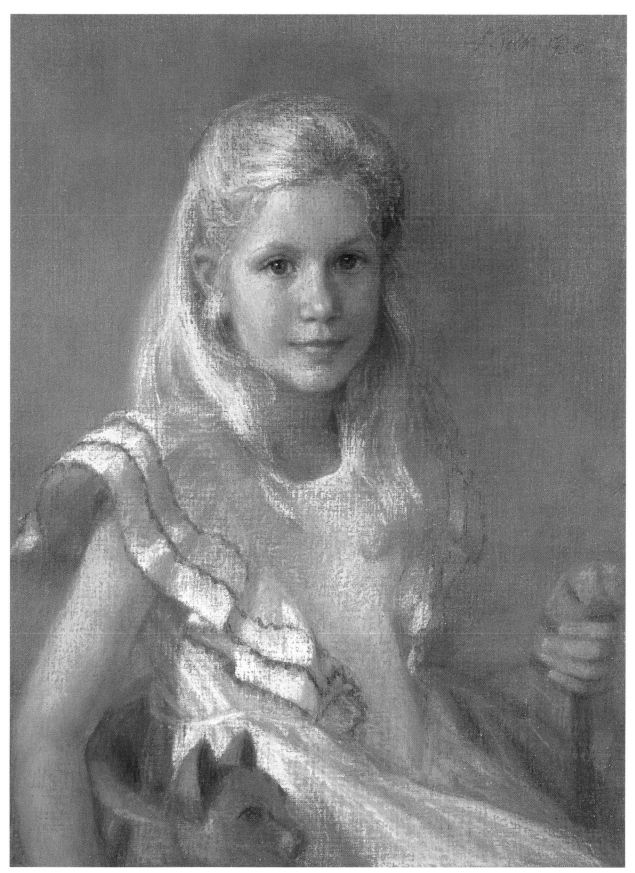

KAY POLK
Countess Christina
Pastel, 26"×20" (66cm×51cm)

5 A RICH VARIETY OF COLORS
Even in this delicate rendering of Christina, Polk used a rich and unexpected variety of colors. Look at the yellow and violet in the face.

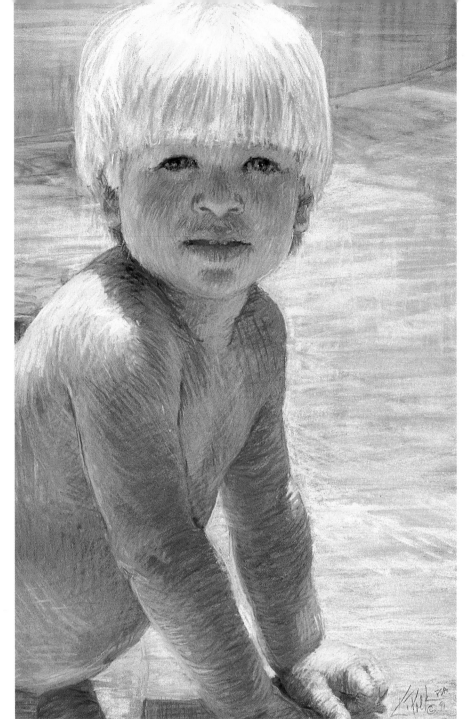

This is an excellent example of how to model form with individual strokes of color. The strokes are especially apparent in the shadowed areas, which are picking up strong reflected color from the environment. From a distance they blend into solid masses of color value, but up close they create a highly textured surface.

KAY POLK
Portrait of Hill
Pastel, 18" × 14" (46cm × 36cm)

DETAIL Looking at the hands and arms you can see how to model form with the direction of the strokes, rounded strokes to show a rounded form.

DETAIL In the areas of bright sunlight, like the top of the boy's head and shoulder, the colors appear bleached out. The shadows, however, pick up all the bright reflected blues, reds, violets and greens of the hot day.

KAY POLK
Douglas
Pastel, 11" × 14" (28cm × 36cm)

Layered Color

LEE HAMMOND

When using Verithin pencils and the layering technique, it is important to remember that the paper you select will help create the color of the drawing. For instance, when using full color, the artist typically uses a warm-toned paper to enhance skin tones, as opposed to using white or gray paper. For this study, Hammond used chamois renewal tinted paper. The quality and size of your reference photo is extremely important as well. You must be able to clearly see the colors in order to replicate them.

Reference photo.

1 GETTING STARTED
Start by placing the photo in a graph. This will allow you to create a more accurate drawing. Since graph lines sometimes hide details, use a copy of your photo to draw the graph, dividing the shapes of the boy's head and shoulders into units. By always having one photo in a graph, you will be able to compare your shapes and placement even after the graph on your drawing has been removed.

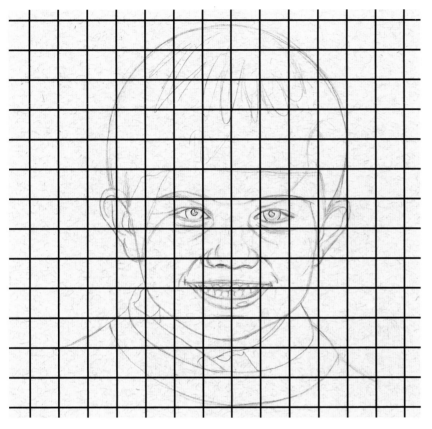

2 THE LINE DRAWING
Using your graph, draw the face and shoulders. Pay particular attention to the details of the features, especially the size and shape of the teeth.

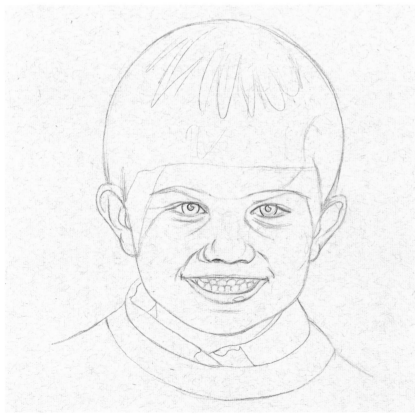

3 REMOVE THE GRAPH
Do not remove the graph lines from your drawing until you are certain that everything is as accurate as possible. When you are satisfied, gently remove the graph lines from your drawing with a kneaded eraser.

4 START WITH THE EYES

Always begin with the eyes, being sure to use a template for the circles. These eyes were rendered with black Prismacolor and Indigo Blue Verithin.

Use a Tuscan Red Verithin for the shadowed areas between the eyes and the temple area. For the eyebrows, apply a layer of Tuscan Red, adding Dark Brown for detail. Transition (or soften) the Tuscan Red areas with a Flesh Verithin, and also add Flesh to the forehead area. Keep a sharp point on your pencils at all times! When the eyes are complete, work your way down to the nose. Render it with Tuscan Red, Terra Cotta and Flesh.

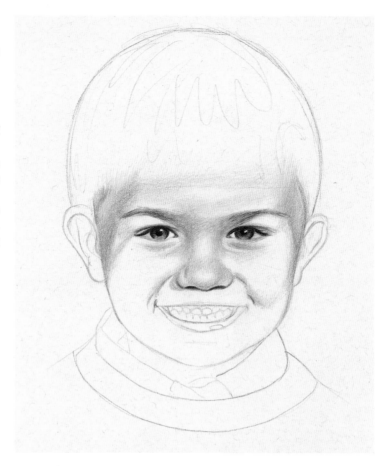

5 DEFINE THE MOUTH

When the nose is complete, move to the mouth (the triangle of features). Draw the lips and gum line with Tuscan Red. Add Flesh to the bottom lip for color. Apply a little black to the inside corners of the mouth to create depth and dimension. With your Tuscan Red, begin to place tone on the outside edges of the face.

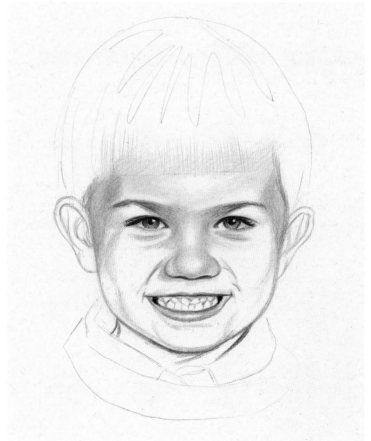

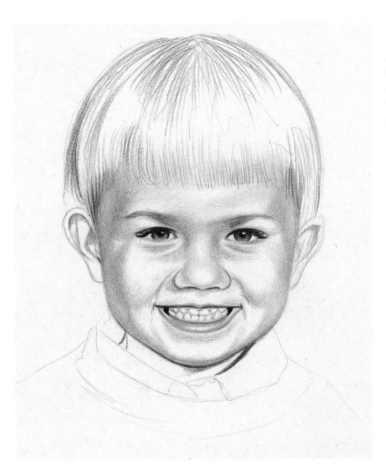

6 ADD SHADOWS AND CONTOURS

Render the shadows and the contours of the face with Tuscan Red. Be sure to work from dark to light. Add a little Flesh color to the gum area on the bottom teeth. With Dark Brown, add some tone and definition under the chin and jaw.

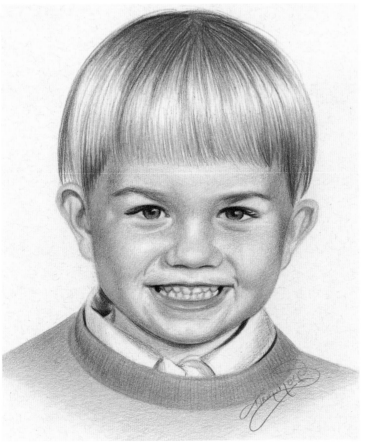

7 FINISH UP

Continue to build the skin tones by adding colors. Apply Terra Cotta next as a transitioning color out of the Tuscan Red—as it would be if going from dark to light on a color value scale. Add Flesh next to soften all of the colors into the color of the paper. Add a small amount of Olive Green to the shadow areas on the left side of the face, neck and temple areas.

When drawing a facial portrait, it is not necessary to include a lot of the clothing. Hammond usually draws the neckline and shoulders, fading out into a *V* shape. Here, the sweater has been simplified and drawn in lightly with Tuscan Red and Scarlet Red Verithins. Light Gray was used for the shadows on the shirt collar. Black and Tuscan Red are found in the shadow next to the neck.

Burnishing Technique

LEE HAMMOND

Burnishing takes a lot more time than layering, so be patient. All of the colors you use must be blended in. This is done by using a lighter color over the existing colors to soften them in gently. It is a back-and-forth, repetitive process that can become tedious, but it also allows you to keep changing your work again and again until it takes on the look you want.

Although the paper surface will be completely covered, Hammond still selected a peach-colored paper, shell renewal. This warm color will add life to the completed drawing, even though the color will not come through in the skin tones like it does with layering. Instead, you will create similar colors with the Prismacolors.

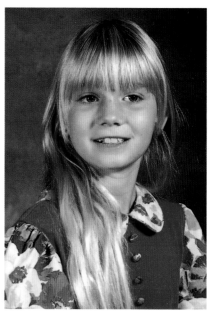

Reference photo.

1 DRAW A LIGHT OUTLINE
Draw a light outline of the face and all of the features with a mechanical pencil. Be sure to get the circles of the eyes accurate by using a template. It is very important not to move on from this stage until you are positive of all the shapes and their accuracy.

2 ALWAYS START WITH THE EYES
Use a black Prismacolor for the pupils and white for the whites of the eyes and the catch light. For the irises, use Indigo Blue. Outline them with black and burnish with white to make them look shiny. For the membrane in the corner of the eyes, use Tuscan Red and Flesh and carry those colors up into the eyelid.

To begin the shadow areas around the eyes and up into the eyebrow area, use a Tuscan Red Verithin.

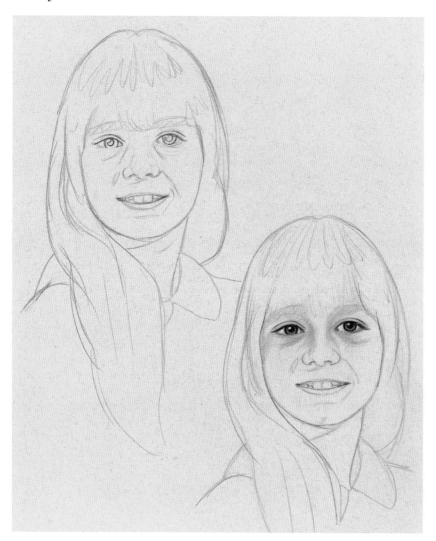

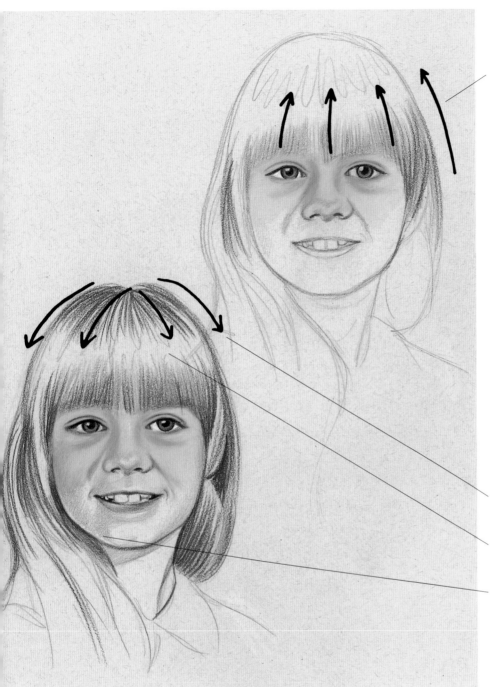

hair direction

3 BURNISH AND SHADE

After adding the shading with the Tuscan Red Verithin, thickly apply Light Peach over it. This is burnishing. You can see that the darker tone underneath still shows through.

Burnish the Light Peach all around the eyes and up into the forehead area, being certain to completely cover the paper. Next, move down to the nose with the Tuscan Red Verithin and apply the shadows there. When you feel that the nose is accurate, burnish it, too, with the Light Peach.

Also start the hair at this stage by applying Dark Brown Prismacolor into the bangs. Start at the ends and use very quick strokes, going up into the area where it is light. (Be sure to have a sharp point on your pencil.)

hair direction

band of light

reflected light

4 WORK AROUND THE ENTIRE HEAD

The mouth is next. Watch the shape of those teeth! Start the lips with Tuscan Red Verithin. Apply Dark Brown Prismacolor into the corners of the mouth and into the little shapes under the teeth.

Begin light shading around the outside edges of the face with the Tuscan Red Verithin. Note: Leave the reflected light around the jawline uncovered. Also, block in the shadow on the neck. To shadow under her eyes, add a small amount of Flesh. Add more of the flesh color to the eyelids, to the forehead where the hair had been placed and to the lips for shine. Continue to work on the hair, adding more Dark Brown into the dark areas. Using the same quick stroke, work from the top of the head downward to the lighter area. Be sure to follow the direction of the hair itself. Return to the bangs and work up using quick strokes to darken them.

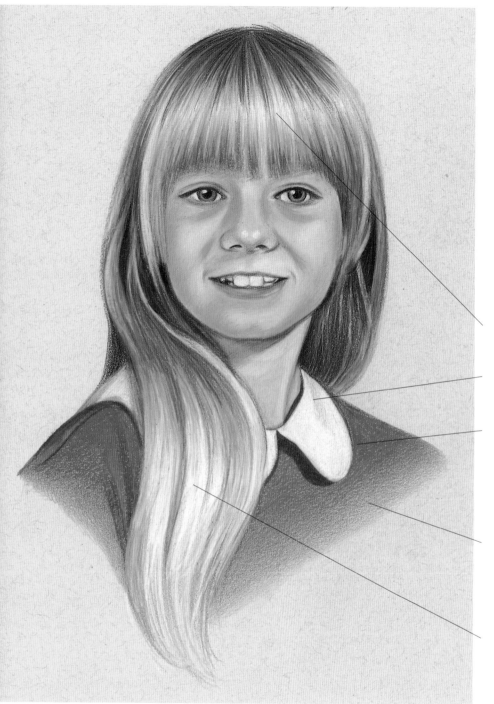

highlights

Burnt Ochre

Prismacolor for color

Verithin to soften

highlights

5 REFINE AND FINISH

To complete the drawing, finish burnishing with the Light Peach Prismacolor. Completely cover the entire face and the neck area. To add more color to the face, add more Tuscan Red and Flesh to the shadow areas. If these tones were lightened too much when burnishing the first time, reapply some color for definition. To finish the hair, add Burnt Ochre, Terra Cotta and Goldenrod to create the blonde colors. Next, burnish those colors with a white Prismacolor. Whenever adding a color, al-ways draw it in, going with the direction of the hair. It is a balancing act of adding dark, medium and light tones until you have created the color you want. But the most important part is the highlights. Highlights should always be applied on top of the other colors and be made to appear as if they are on the outer surface of the hair.

If you compare Hammond's drawing with the photo, you will see that she smoothed out the hair to make it appear more styled and attractive. You, as the artist, always have the option of improving on nature.

Draw in the collar of the dress with a white Prismacolor, adding some shadow using the Burnt Ochre seen in her hair. Simplify the dress so it does not compete with the face. Use a Scarlet Lake Prismacolor to fill in the color and soften it toward the bottom with a scarlet Verithin. For the shadow under the collar and on the shoulder, use the Dark Brown Prismacolor and add some highlights on the shoulder with white.

Vertical Stroke Technique

ANN KULLBERG

Ann Kullberg developed her vertical line technique to accelerate the process of colored pencil painting and, when desired, to create a sense of movement in otherwise static areas such as backgrounds. The technique is simple: color is layered with vertical strokes, the length determined by the amount of space to be colored. Smaller areas are layered with short strokes and larger areas with longer strokes. Colors are layered on top of each other within vertical strokes using light pressure at first, then increasing it as color is added. Kullberg rarely burnishes her paintings, preferring to have the surface show through.

PALETTE

- Peach
- Orange
- Goldenrod
- Pumpkin Orange
- Mineral Orange
- Pale Vermilion
- Sienna Brown
- Burnt Ochre

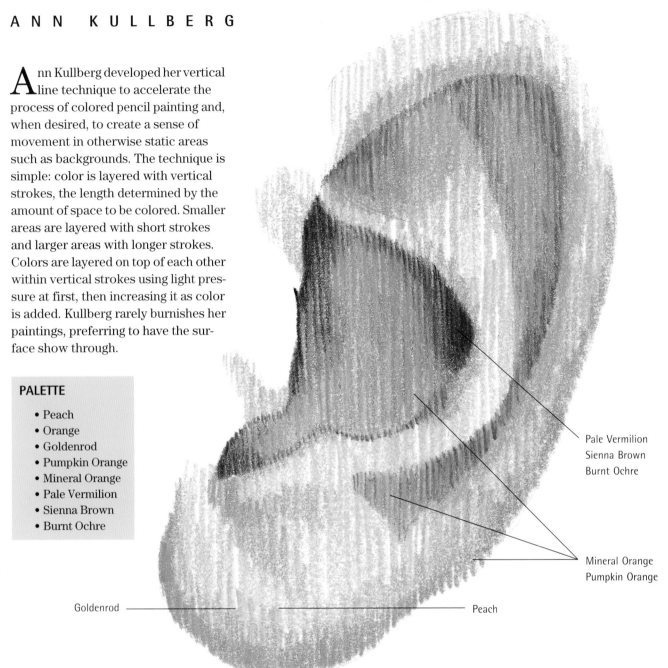

Pale Vermilion
Sienna Brown
Burnt Ochre

Mineral Orange
Pumpkin Orange

Goldenrod

Peach

CAUCASIAN SKIN

1 Layer Peach over the entire area.

2 Layer Orange for darker values.

3 Layer Goldenrod over entire area.

4 Layer Pumpkin Orange over Mineral Orange.

5 Layer Pale Vermilion, Sienna Brown and Burnt Ochre in darkest areas.

Note: Strokes are shown farther apart for example only.

CAUCASIAN HAIR

1 Outline with Goldenrod.

2 Layer darker areas with Yellow Ochre and Goldenrod.

3 Layer Deco Yellow, Burnt Ochre, Terra Cotta and Dark Brown.

4 Layer Pumpkin Orange over Mineral Orange. Layer highlights with Canary Yellow, Warm Grey 10% and Warm Grey 20%. Layer darkest areas with Dark Umber.

Middle-Aged Woman

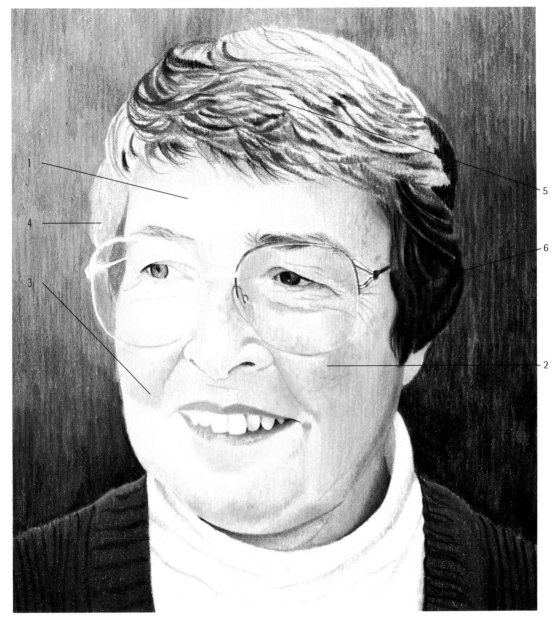

PALETTE

Skin
- Cream
- Blush Pink
- Light Peach
- Cool Grey 20%
- Yellow Ochre
- Light Umber
- Mineral Orange
- Dark Brown
- Jasmine
- Goldenrod
- Orange
- Warm Grey 30%
- Burnt Ochre
- Terra Cotta
- Dark Umber
- Warm Grey 10%
- Celadon Green

Hair
- Warm Grey 30%
- Goldenrod
- Burnt Ochre
- Dark Brown
- Light Umber
- Deco Blue
- Deco Yellow
- Terra Cotta
- Tuscan Red
- Dark Umber
- Black
- Indigo Blue

SKIN

1 Layer Cream, Blush Pink, Light Peach, Cool Grey 20%, Yellow Ochre and Light Umber.

2 Layer Blush Pink, Mineral Orange, Dark Brown and Jasmine.

3 Layer Goldenrod, Orange, Light Umber, Mineral Orange, Blush Pink, Warm Grey 30%, Burnt Ochre, Terra Cotta, Dark Umber, Warm Grey 10% and Celadon Green.

HAIR

4 Layer Warm Grey 30%, Goldenrod and Burnt Ochre.

5 Layer Dark Brown, Light Umber, Deco Blue and Deco Yellow.

6 Layer Terra Cotta, Tuscan Red, Dark Umber, Black, Indigo Blue and Dark Brown.

Adult Man

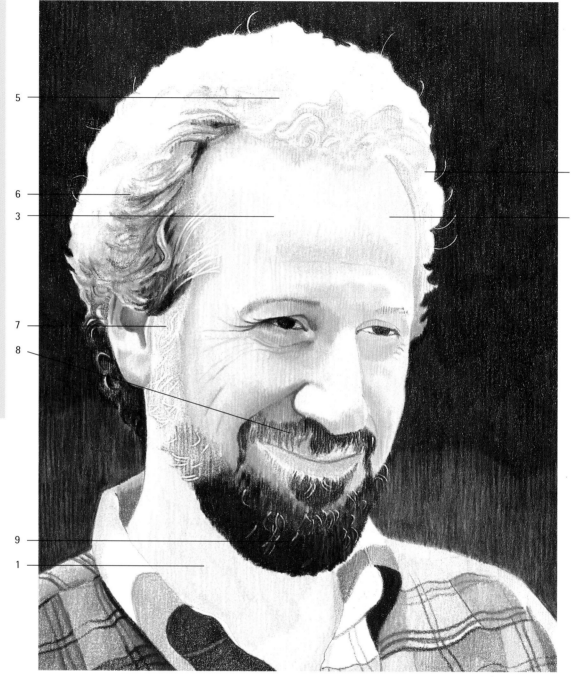

PALETTE

Skin
- Light Peach
- Jasmine
- Peach
- Light Umber
- Blush Pink
- Mineral Orange
- Burnt Ochre
- Pumpkin Orange
- Yellow Ochre

Hair
- Warm Grey 20%
- Lavender
- Warm Grey 30%
- Light Umber
- Dark Umber
- Black

Facial Hair
- Cool Grey 50%
- Light Umber
- Dark Umber
- Tuscan Red
- Black
- Warm Grey 10%

SKIN

1 Layer Light Peach and Jasmine.

2 Layer Peach, Light Umber and Blush Pink.

3 Layer Mineral Orange, Burnt Ochre, Pumpkin Orange, Yellow Ochre and Light Umber.

HAIR

4 Layer Warm Grey 20% and Lavender.

5 Layer Warm Grey 30%.

6 Layer Light Umber, Dark Umber and Black.

FACIAL HAIR

7 Impress line Cool Grey 50% (sideburn).

8 Layer Light Umber and Dark Umber (mustache).

9 Layer Tuscan Red, Black and Dark Umber. Burnish Warm Grey 10% (beard).

African-American Young Man

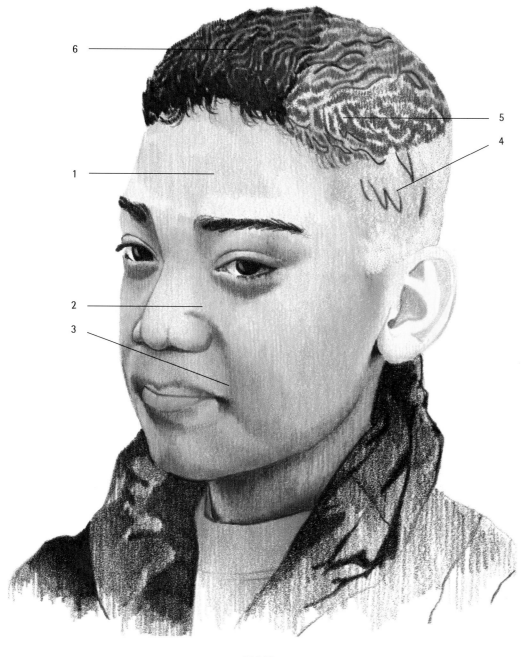

SKIN

1 Layer Goldenrod, Cream and Mineral Orange.

2 Sienna Brown, Burnt Ochre, Blush Pink and Goldenrod.

3 Burnt Ochre, Light Umber, Pink and Pale Vermilion.

HAIR

4 Layer Black, Dahlia Purple and Cloud Blue.

5 Layer Peach and Warm Grey 50%.

6 Layer Black and Sienna Brown.

Asian Girl

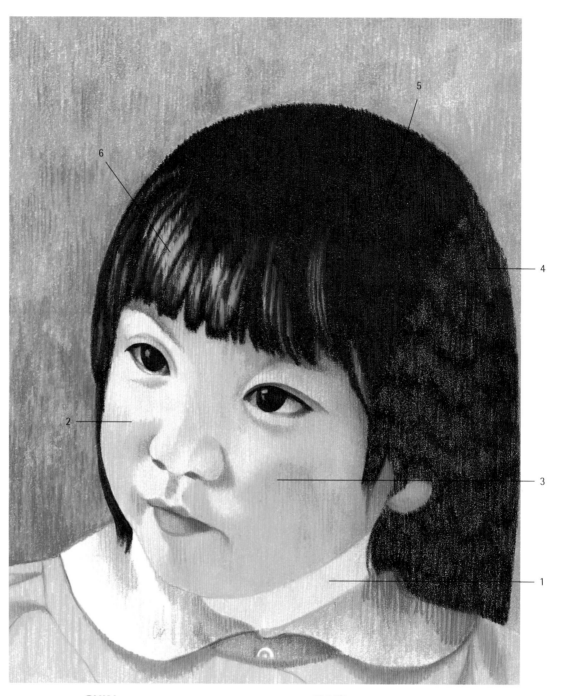

SKIN

1 Layer Jasmine and Light Peach.

2 Layer Yellow Ochre, Blush Pink and Burnt Ochre.

3 Layer Yellow Ochre, Blush Pink, Mineral Orange and Pink. Burnish Jasmine.

HAIR

4 Layer Tuscan Red and Black.

5 Layer Indigo Blue. Burnish Black.

6 Layer Deco Blue, Warm Grey 30%, Mediterranean Blue and Dark Umber. Burnish White.

INDEX